WIDE-ANGLE LENS
PHOTOGRAPHY

JOSEPH PADUANO

AMHERST MEDIA, INC. ■ AMHERST, NEW YORK

Copyright © 1996 by Joseph Paduano

All rights reserved.

Published by:
Amherst Media Inc.
P.O Box 586
Amherst, NY 14226
Fax: 716-874-4508

Publisher: Craig Alesse
Editor/Designer: Richard Lynch
Associate Editor: Frances J. Hagen
Contributing Editor: Daniel Paul Schwartz, J.D., Ph.D.
Photos by: Joseph Paduano

ISBN: 0-936262-43-5
Library of Congress Catalog Card Number: 95-80949

Notice of disclaimer: The information contained in this book is based on the author's experience and opinions. The author and publisher will not be held liable for the use or misuse of the information in this book.

Printed in the United States of America
10 9 8 7 6 5 4 3 2 1

Acknowledgements

Much thanks to: Minolta Corporation, especially Mark Wayne; Sigma Corporation; everyone at Dorn's Photo Shop in Red Bank, especially Bill Matlack, Dan Dorn, Barbara Engel, Kathy and Pizza pals, Nancy and Gail; Andre Grastyan; Capt. Ron Weinstein; Joe and Betsy Rosati and the boys, Jesse, Cameron and Alex; Little Debbie; Collis Blend; Jeanne Bley; and of course, Craig Alesse at Amherst Media for the opportunity to produce this book.

TABLE OF CONTENTS

INTRODUCTION

Welcome to the World of Wide-Angle Lenses

Try Something New

If you're tired of shooting most of your photographs using a standard 50mm lens and would like to try something new, try a lens that will help you see familiar subjects in brand new ways. The result might be more variety, interesting viewpoints and a unique perspective. What you need is a new angle, both figuratively and literally. Look no further — wide-angle is the answer! A whole new view of the world and the world of photography will open up for you. There are a number of reasons to choose a wide-angle lens over another lens. To begin with, these lenses produce an extremely expansive angle of view. When you want to capture more of a scene on film, wide and ultrawide-angle is the way to go. To convey a panoramic look and feeling to landscapes, you want to take advantage of the ability of a wide lens to record larger spaces. Also, you will retain sharp focus from foreground to background due to the great depth of field produced by these lenses.

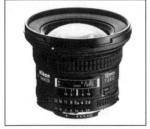

Nikon 18mm f/2.8D AF Nikkor wide-angle lens.

Popular Tools of Photography

Wide-angle lenses are becoming one of the most popular tools of photography. Once you begin shooting with wide-angle, you will never look at your subject matter the same way again. You will have fun discovering the wonderful images you can create, and rediscover the joy of photography by using a wide lens and a keen eye. The new wide-angle and ultrawide-angle lenses are easy to use, care for and appreciate. Naturally, there are some adjustments you must make when composing a scene and deciding on your camera viewpoint. However, these are minor adjustments compared to the major advantages of using a wide-angle lens.

Most photographers start out using a 50mm lens mainly because that is the lens that comes with almost every camera body. I also used a 50mm lens when starting out in photography, not realizing the limitations of the lens. Looking back, I see just how much more of a challenge it was to make an interesting, creative image. My photographs were good, but I felt something was lacking. I could not capture a scene on film the way I had pictured it in my mind or how I thought the lens would record it. You need the right equipment to be able to collect your ideas and transfer

"...YOU WILL NEVER LOOK AT YOUR SUBJECT MATTER THE SAME WAY AGAIN."

them onto film. The 50mm lens got old quickly, but it was a great lens to learn with and I was able to take what I learned and apply it to wide-angle photography. The shortcomings of the 50mm forced me to find other lenses that would stimulate my creativity.

Creating Dynamic Images

For me, there was no bigger thrill in photography than when I first used a wide-angle lens. I felt as if I were a movie director looking through the viewfinder, walking around and moving the camera from side to side. I marvelled at the expansive view the lens captured and the sense of space it created. I knew that this was the lens that would enable me to realize the kinds of images I knew I was capable of creating. With a wide-angle lens and my imagination, I could now create images that were unique, dynamic and personal. I now shoot most of my photographs with wide and ultrawide-angle lenses in order to produce images containing strong visual impact as a result of incorporating many elements in a scene.

The lens that gets the most use, especially when I travel, is a 24-70mm wide-angle zoom lens. Wide-angle zooms offer the most versatility of all the wide-angle lenses. By using a zoom, you have a great variety of lenses all built into one lens. This allows you to quickly choose the lens you feel will work best in any shooting situation. You don't have to concern yourself with changing lenses in the middle of a shooting session, which can be frustrating, time consuming and the cause of many missed photo opportunities. Using a wide zoom lens allows you to carry less equipment which also means your camera bag will be much lighter!

I recently traveled to a hot air balloon festival and was able to shoot many photographs that would have been difficult to take with any other lens. It is the most versatile and consistently used lens that I own. From the ground, I was able to photograph balloons in the foreground that were waiting to ascend and also include dozens of balloons already ascending in the background. (These shots were made with the 24mm and 28mm of the zoom.) As the rest of the balloons left the ground, I was able to quickly zoom to longer focal lengths and capture them as they drifted farther away. Even though the balloons moved so quickly, I was able to react in a split second to follow them. I didn't have to worry about missing any shots with all these lenses built into a single lens.

One day I took a hot air balloon ride and was surrounded by 75 balloons of all shapes and sizes. I used the 24mm setting on my zoom lens to capture part of the balloon I was in and include the nearby balloons, all in one wide, wonderful shot. I also used the 24mm lens to record a wide scene of all the surrounding balloons and distant hills. I then zoomed to 28mm to isolate two or three balloons together in the not too distant sky, and then zoomed to 40mm and 70mm to capture the more distant balloons. I can't imagine being in a more restricting shooting situation than being confined to that small basket. Because I had my wide-angle zoom, I had the luxury of being able to shoot as wide or as narrow a view as quickly as I wanted without having to change lenses or add accessories. I was even able to lean out of the basket and get a shot of the tops of four

WHY USE A WIDE-ANGLE LENS?

• To produce images with strong visual impact by incorporating many elements in a scene.

balloons directly below the basket of my balloon using the 70mm setting. Against a field of dark green grass, they took on the appearance of giant colorful flowers, springing up from the ground. Using my wide-angle zoom lens made shooting in a tight situation with constantly changing scenery and fast moving objects quick, easy and convenient. It was the perfect lens to use in a situation where I didn't have the time to change lenses or worry about missing shots I might never get again.

What You'll Learn

You can certainly increase your photographic knowledge and enhance your technique and portfolio with the endless possibilities afforded you by the use of wide-angle lenses. They can help you explore ways to better express yourself through the creation of exciting photographic images.

This book lists the different types of wide-angle lenses that are available and the specific features of each lens. It will enable you to select the wide-angle lens or lenses that are best suited to your photographic style and needs. It will also show you how to use wide-angle lenses effectively and creatively to improve your picture taking abilities. You will learn about shooting techniques, vacation and landscape photography, architectural and interior photography, and advanced shooting tips. In addition you will learn how to take proper care of your lens. You will also discover the joy of wide angles of view, exaggerated perspectives and image distortion.

THIS BOOK WILL HELP YOU:

- Select the right wide-angle lens

- Use wide-angle lenses effectively and creatively

- Learn general and advanced shooting techniques

- Take better vacation, landscape, architectural and interior photos

- Discover the joy of wide-angle views, exaggerated perspectives and image distortion!

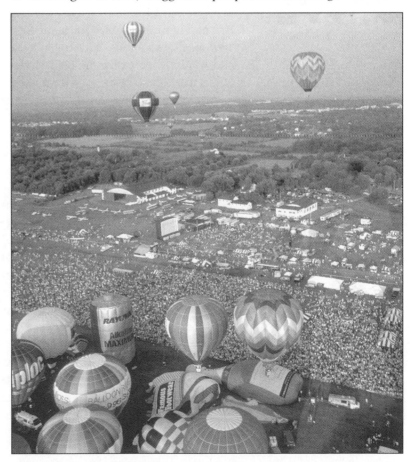

CHAPTER 1

Key Features of Wide-Angle Lenses

Angle of View

The *angle of view* is the specific degree of coverage of the lens. It is a diagonal measurement, in degrees, of the area in a scene covered by the lens at a given distance. A 50mm lens limits the size of an area that is recorded because it has a 47° angle of view, which is narrow. This tends to isolate areas of a scene and can result in static, claustrophobic images. The area of a scene recorded by a wide-angle lens is greater than that of a 50mm lens (at the same distance) due to its extreme angle of view. For wide-angle lenses, the angle of view ranges from 62° to 84°, and from 94° to 118° for ultrawide-angle lenses, and an incredible 180° for fisheye lenses. Wide-angle lenses spread subjects out in length and width by increasing the field of view and expanding the image.

To make the best use of wide-angle lenses, use a camera with 100% viewing which allows you to see everything the lens is recording in a scene. Using a camera with less than 100% viewing will allow elements that won't be visible in the viewfinder to be recorded on film. These elements are found around the extreme edges of the frame.

The Amount of Coverage

The amount of coverage wide-angle lenses record over other lenses is impressive. A 35mm lens covers twice the area of a 50mm and a 24mm lens covers twice the area of a 35mm, and four times the area of a 50mm. A 20mm covers 45% more area than the 24mm lens, three times the area of a 35mm, and six times the area of a 50mm lens. Ultrawide-angle lenses record even more of an area of a scene than wide-angle lenses. A 13mm ultrawide-angle has twice the coverage of a 20mm and fifteen times more coverage than a 50mm. A 17mm has 50% more coverage than a 20mm, four times that of a 35mm, and nine times more than a 50mm.

Wide-angle lenses are invaluable when shooting indoors with restricted space, or shooting group shots, spacious scenic views and large buildings. Most interior shots of homes and buildings are shot with wide lenses in order to fit in as much of an area as possible. You cannot do that with any other lens.

ANGLE OF VIEW

The amount of area covered or viewed by a lens.

From the same distance, a wide-angle lens covers an area greater than that of a normal (50mm) lens.

"...INVALUABLE WHEN SHOOTING INDOORS WITH RESTRICTED SPACE..."

Comparing the Angle of View of Various Lenses

18mm lens

20mm lens

24mm lens

28mm lens

35mm lens

50mm lens

Comparing the Angle of View of Various Lenses

60mm lens

70mm lens

80mm lens

100mm lens

150mm lens

200mm lens

Depth of Field

Wide-angles also differ from other lenses in that they provide an increased depth of field. Depth of field is the term given to the range behind, and in front of, a subject you are focused on where the subject still appears acceptably sharp. Depth of field is determined by three factors: the size of the aperture (lens opening); focal length of the lens; and the distance at which the lens is focused. The short focal length and increased depth of field ensure that almost all areas of a scene from foreground to background will remain in sharp focus with wide and ultrawide-angle lenses.

These features also help to minimize camera shake and allow you to use slower shutter speeds. You can handhold your camera using shutter speeds from as low as 1/30 second down to 1/15 second when using ultrawide-angle lenses. Even when using wider apertures, depth of field will remain relatively sharp. Wide and ultrawide-angle lenses also allow you to focus very close to your subject. The minimum focusing distances range from about 12 inches for most wide-angle lenses to 6 inches for most ultrawide-angle lenses. Wide-angle zooms however, only allow a minimum focusing distance of about 18 inches.

Image Distortion

The other major difference between wide-angle or ultrawide-angle lenses and other lenses is the fact that wide-angle lenses produce *image distortion*. They increase the size of objects which are closer to the camera in relation to the background, and decrease the size of objects that are distant. The wider the angle of the lens, the greater the image distortion becomes. Distortion becomes more apparent when close to the subject; the camera is not in a level position; and elements are near the extreme edges of the frame. As you can imagine, making size and perspective look realistic can be a challenge.

Fisheye Lenses

The most extreme distortion is found in fisheye lenses. A circular fisheye produces a completely round image and covers 180°. It produces startling effects by overexaggerating perspectives. Straight lines curve with this lens, except those directly in the center of the frame. Because of barrel distortion, straight lines in the center of the frame bulge outward toward the film plane and appear to be straight.

The nearer the straight line is to the frame edge, the more the line will noticeably bow outward to the edge of the frame. A full frame fisheye does not produce a round image, but still covers a 180° view creating extreme distortion by curving or bending straight lines across the full frame of the film.

Rectilinear Wide-Angle Lenses

The least image distortion is found in rectilinear wide-angle lenses. Most of the new wide-angle and ultrawide-angle lenses are of a

rectilinear design which keeps straight lines straight to minimize distortion. Distortion with ultrawide-angle lenses is minor but more obvious when shooting indoors in confined spaces. When shooting horizontals from a close, level position to the subject, distortion appears in the form of elongated lines at the frame sides. When shooting from a low position and tilting up, the distortion is in the form of converging lines at the top of the frame. When shooting verticals close — not level to the subject — and the camera is tilted down, lines elongate in the foreground. Conversely, when the camera is tilted up, lines converge at the top of the frame.

Minimizing Distortion

Remember to minimize distortion by shooting level to the subject, and placing the camera half way between the top and bottom of the scene. Because you can control the distortion to some extent, the best way to get the most out of your wide-angle lenses is to use the distortion to your advantage. Incorporate it into your photographs when it will enhance the image rather than detract from it. You decide how much or how little distortion you want through lens choice, camera viewpoint, and composition.

> **"YOU DECIDE HOW MUCH OR HOW LITTLE DISTORTION YOU WANT..."**

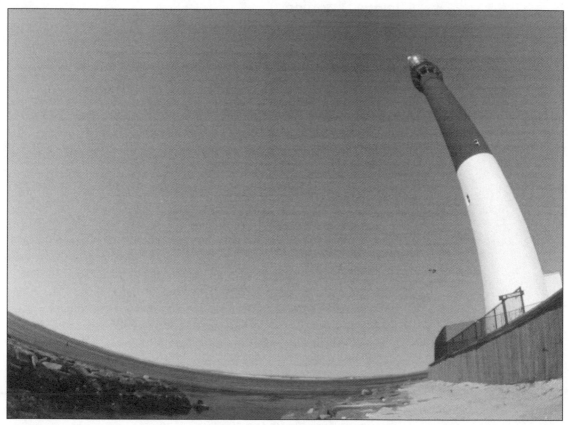

Curving and bending lines caused by the extreme distortion produced by a full frame fisheye lens. The camera was tilted up from a low position for this shot. The shot was taken with a Minolta 16mm f/2.8 fisheye and orange filter.

SPHERICAL DISTORTION

Occurs when a lens bends light rays passing through the edges more than those passing through the center so that they don't reach a common focal point on the film.

The distortion produces unsharp, low contrast images.

LENS FLARE

A decrease in contrast in the shadow areas of an image due to the reflection of light from lens surfaces and internal elements in the lens barrel. It is most likely to occur when shooting backlighted subjects.

Multi-coated lenses reduce lens flare and improve the quality of the image.

"THE CONSTRUCTION OF A WIDE-ANGLE LENS DIFFERS FROM THAT OF A STANDARD LENS."

Lens Speed

Lens speed is an important factor to consider when choosing a wide or ultrawide-angle lens. Lens speed is a term given to a lens based on its largest aperture. Lenses are classified as either fast or slow. A fast lens is preferable to a slow lens, especially when shooting under low light conditions. Fast lenses produce brighter images in the viewfinder which makes focusing easier. They also allow you to shoot in lower light situations. For example, a 28mm f/2.8 is considered a fast lens because it allows a maximum aperture of f/2.8. A 28mm f/3.5 lens is considered slow because of a maximum aperture of only f/3.5. The faster f/2.8 lens allows a greater amount of light to reach the film than the f/3.5 lens when both are set at their respective maximum apertures.

F/Stop

The f/stop numbers are ratios between the diameter of the lens opening (aperture) they represent and the focal length of the lens. For example, f/11 means the aperture opening is 1/11, the focal length of the lens. F/4 means the opening is 1/4 the focal length of the lens.

The aperture represented by each successive larger f/stop number permits half as much light to reach the film as the previous number. For example, f/16 transmits half as much light as f/11. Therefore, an aperture of f/8 allows four times as much light in as f/11 because its diameter is twice as large as f/11.

F/stop is the term that indicates the size of the aperture opening. The f/stop numbers can be found on either the f/stop ring of the lens barrel or the display screen of some camera bodies. The f/stop is used to control the amount of light that reaches the film (exposure) and the depth of field. The smaller the f/stop number, the larger the aperture opening, resulting in a decrease in the depth of field. The larger the f/stop number, the smaller the aperture opening, resulting in an increase in the depth of field.

Spherical Distortion and Lens Flare

The construction of a wide-angle lens differs from that of a standard lens. As light rays travel through the many elements that compose a wide-angle lens, they are viewed by the lens and focused on the film at greater angles than with standard lenses, inducing *lens flare* and *spherical distortion*. Bulk is also increased due to the many lens elements needed to produce greater coverage. It can be difficult to optically correct and prevent lens flare and other spherical distortions, but the greater curvature of field of a wide lens must be corrected or flattened out across the film plane. One way to achieve this is to reduce the maximum aperture of the lens, but this slows down the speed of the lens.

Correcting These Problems

To correct lens flare and spherical distortion without reducing the maximum aperture of the lens, the use of a spherical lens must be

ASPHERICAL LENS

A lens that incorporates special optical characteristics that minimize internal reflection and eliminate spherical distortions that contribute to image softness.

These lenses focus the light evenly across the film plane for improved image sharpness and contrast.

avoided. Spherical lenses bend light rays that pass through the edges of a lens more than those that pass through the center. This results in reduced image sharpness and contrast and induces lens flare. To correct these aberrations, *aspherical lens* elements are being incorporated in the design of wide and ultrawide-angle lenses. Some designs also include floating lens elements where certain lens components move independently during focusing.

This type of construction eliminates curvature of field, corrects flare and optic distortion, and reduces bulk while maintaining a wide maximum aperture to ensure a fast lens. Because the floating lens design uses fewer lens elements, the lenses are small and lightweight with less internal reflection. This construction also maintains high resolution, minimizes image softness, and enhances contrast and color fidelity. A blurred border around a subject known as an arrow shaped coma, can produce an uneven exposure. The aspherical design incorporated in wide-angle lenses corrects this problem and allows full corner-to-corner illumination. This ensures a sharp, superior image and prevents light fall off. Many wide-angle zoom lenses now incorporate aspherical elements in their design.

Internal Focus/Zoom Systems

Finally, many new wide-angle zooms are equipped with internal focus/zoom systems which allow the lens to be focused and zoomed without changing the length of the lens barrel. This makes the lens operation easier, and allows you to shoot at shorter distances. With autofocus (AF) lenses, this feature increases the autofocus response time. The internal focusing system also prevents the front lens element from rotating which makes it easier to work with filters. This is especially handy with polarizing filters because once you turn the polarizing ring to achieve the maximum effect, you don't have to readjust it after focusing.

Holding the Camera

Holding the camera and lens properly will aid you in focusing and changing f/stops and shutter speeds. It will also help with zooming in and out quickly and easily when using a wide-angle zoom lens. Rest the bottom of the camera and lens in the palm of your left hand and wrap your fingers up around the lens barrel. This will give you easy access to the focusing collar and f/stop ring on a fixed focal length lens, as well as the zoom collar on a wide-angle zoom lens. Note: Some zooms have one collar for both zoom and focus operation. With the index finger of your right hand, you can operate the shutter button and you also have easy access to many of the camera's operating controls. Next, bring the viewfinder up to your eye, rest the top of the camera against your forehead and tuck both elbows into your torso. This method of handholding your camera and lens will help eliminate camera shake and make control of your equipment much easier and more efficient.

"THIS METHOD WILL HELP ELIMINATE CAMERA SHAKE..."

CHAPTER 2

Types of Wide-Angle Lenses

A VARIETY OF LENSES TO CHOOSE FROM:

- **Single focal length wide-angle lenses**

- **Ultrawide-angle lenses**

- **Wide-angle zoom lenses**

Tokina 24-40mm f/2.8 AT-X 240 AF wide-angle zoom lens.

Variety of Lenses

There are so many lenses on the market today that no matter what brand of 35mm camera you own, there is a wide or ultrawide-angle lens made for it. There are plenty of lenses to choose from including a single focal length lens, a wide-angle zoom, fisheye, or special purpose wide-angle lens. If you already own a wide-angle lens, you might consider upgrading or adding to what you already have, perhaps a wide-angle zoom that incorporates many lenses in one for convenience and versatility. Please see Appendix B for a list of wide-angle lenses and manufacturers

This variety of lenses includes: the fixed focal length wide-angle lenses most photographers use (the 24mm, 28mm and 35mm); the ultra-wide-angle lenses most commonly used (the 20mm and 18mm); and the wide-angle zoom lenses most preferred (the 20-35mm, 24-50mm and 28-70mm).

Wide-Angle Zooms

There are new wide-angle zooms that offer a tremendous range of 28 to 200mm! When using this particular zoom, you have access to a variety of wide-angle and telephoto lenses all incorporated into one lens. You have a 28mm that is wide enough to photograph architecture, landscapes and interiors. You also have a 200mm that is strong enough to bring a far off object in close to capture detail, plus all the lenses in between that also permit you to make candids and portraits.

The only drawback with this lens is that sharpness and lens speed are sacrificed somewhat. The lens speed is usually between f/3.5-5.6, which really isn't all that slow, especially when you can make up for it by using the newer low grain, fast films. Because wide-angle zooms incorporate many lenses within a single lens, even those not offered as fixed focal length wide-angle lenses can be part of the zoom.

For example, with a 24-50mm wide zoom, you have a 26mm lens and a 30mm lens which are two lenses not offered as fixed focal length lenses. You can compose a shot quickly and efficiently with wide zooms and eliminate the need to buy many separate lenses and filters. You will also have less equipment and weight to carry around.

"...DISCUSS YOUR NEEDS, CONCERNS, AND PRICE RANGE WITH YOUR CAMERA DEALER."

Tamron 28-200mm zoom f/3.8-5.6 lens.

Lens Quality

All of the manufacturers listed in Appendix B make lenses with superior optics and elements, light-weight designs, and ease of handling. Many photographers feel that "name" brand lenses produced by the camera manufacturers are superior to lenses produced by independent manufacturers. However, there are many photographers who feel there is no perceptible loss of quality in lenses not manufactured by the maker of the camera. Independent lens makers produce lenses that are optically excellent and offer good value. To help you decide on a lens, check the manufacturer's literature, review lens tests and discuss your needs, concerns, and price range with your camera dealer.

Zoom Lenses

Like fixed focal length wide-angle lenses, wide and ultrawide-angle zooms can include many unwanted elements in a scene. However, with a zoom lens, you can just zoom in or out to remove unwanted objects. A zoom lens can alter the image size quickly and keep the distance unchanged between the camera and subject. Zooms allow you to alter your composition quickly, produce a varied amount of unique "views," and also make cropping a scene easier.

A variable f/stop feature allows the new wide-angle zooms to have a short, compact design and much lower price tag. Wide zooms offer as sharp an image as a fixed focal length lens. For prints as large as 16 x 20, there is not a noticeable difference in quality between images made with wide zooms and those shot with a fixed focal length lens. Because these zooms are small and lightweight, they easily lend themselves to being handheld in most situations. When using a wide zoom that goes beyond an 80mm, a tripod is advised.

Variable Focus Design

Most of the new wide zooms are equipped with a variable focus design which is a two-ring system of operation; one ring for the zoom control, and a separate ring for focusing. This is a little slower than using a zoom that has a single push-pull collar that allows you to zoom and focus all in one operation. The trick to using a two-ring system is to zoom to the maximum focal length, focus, then zoom to any focal length you want and the subject will remain in focus. With practice, this becomes as simple as using a single-collar zoom.

Note: Many wide-angle zooms include a separate setting for macro photography that allows you to focus extremely close to objects. You can focus as close as six inches with a 1:4 magnification ratio, or 1/4 life size on film. This enables you to fill the image area with a small subject and retain critical sharpness and detail.

Fisheye Lenses

Fisheye lenses are the least used wide lenses, partly due to cost and limited application. One type of fisheye lens is the *circular or "true"*

CIRCULAR FISHEYE LENS

A wide-angle lens with a 180° angle of view that produces a circular image on film. The lens exaggerates perspective and causes outrageous distortion, especially around the edges of the image area.

Sigma 15mm fisheye lens

fisheye which is usually a fixed focus 8mm lens, has a 180° angle of view, and produces a round image with a high degree of barrel distortion. This results in a photo that renders effects similar to those of reflections in a doorknob.

It is a very expensive lens, with limited applications. Due to the tremendous field of view, it is also a bit tricky to use. The other type of fisheye lens that is used more often, and can be applied to many more shooting situations, is a full frame fisheye. It is usually a 15mm or 16mm lens, and also has a 180° angle of view, but does not produce a round image. It produces high image distortion (barrel type, see page 23) by bending straight lines across the entire frame of film. It is less expensive than the circular fisheye, but has more practical applications and is easier to operate. It is the fisheye lens preferred by most photographers. There is also a 17-28mm fisheye zoom lens available from Pentax that produces the fisheye effect at all focal lengths, with a true 180° fisheye effect at the 17mm setting.

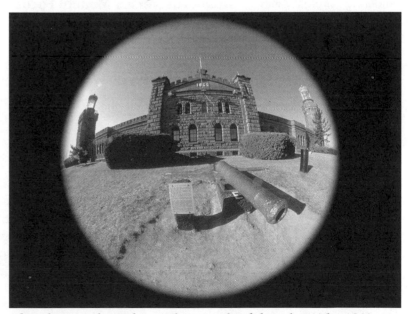

This photograph is taken with a circular fisheye lens. The 180° angle of view produces a round image with a high degree of barrel distortion. The shot was taken with a Minolta 7.5mm f/4 fisheye lens with a yellow filter.

Using a Fast Lens

Use a fast lens to shoot in lower light, and faster shutter speeds to freeze action and avoid camera shake. For example, a lens with a maximum aperture of f/2.8 can be used in light that is two times darker than a lens with a maximum aperture of f/4 or four times darker than a f/5.6 lens. Faster lenses are often slightly larger and cost more than slower lenses, but the advantages outweigh the cost.

With some wide zooms, the lens speed or maximum aperture (f/stop) remains constant which means it maintains the same maximum aperture throughout the entire zoom range. With other models, the speed or f/stop is variable, meaning the effective f/stop of the lens changes throughout the entire zoom range as the focal length of the lens is increased or decreased. The speed of the lens will diminish as the focal length increases.

For wide-angle zooms, an excellent constant aperture would be f/2.8, and a good variable aperture would be f/3.5-4.5 or better. For fisheye, tilt, or PC (Perspective Control) lenses, f/2.8 is a good speed.

Lens Construction

RECTILINEAR LENS

A wide or ultrawide-angle lens that corrects both kinds of distortion (barrel or pincushion) by curving or bending lines, thereby rendering straight lines straight.

The other factor to consider when choosing a wide-angle lens has to do with lens construction. Many of the new wide-angle and ultrawide-angle lenses have aspherical designs; some are rectilinear and some incorporate both of these features. *Rectilinear lenses* keep straight lines straight across the image area rather than bending or curving the lines, thereby minimizing image distortion.

Autofocus Versus Manual Focus

The subject of autofocus versus manual focus with wide-angle lenses is up for debate. Some photographers feel that autofocus helps you focus faster so you don't have any missed photo opportunities, especially when taking action shots. Some newer autofocus cameras keep a constant focus while you follow a moving subject by determining how fast the subject is moving.

Focusing on the Main Subject

One drawback to autofocus is that once you compose your shot and focus on the main subject, the camera will set the focus at the subject to camera distance. Once you move the camera off the main subject to recompose or alter the camera viewpoint, you will have to refocus the lens. Also, if the subject is outside the focus frame area of the lens, the camera will focus the lens on an area beyond the subject to camera distance. This can be time consuming and cause you to miss a good photographic opportunity.

One way to avoid this problem is to switch to manual focus, or use the focus lock mechanism if your camera is equipped with this feature. To lock the focus on the subject, you must place the subject in the center of the focus frame area and hold the shutter button partway down.

You can then place the subject outside the focus frame area and press the shutter button all the way down to take the shot.

Controlling the Depth of Field

Another problem with autofocus occurs when controlling the *depth of field.* For example, let's say you are focused on a subject about 10 feet away and you want to blur the background to isolate the subject, yet still keep the subject in sharp focus. You can do this by opening the aperture to about f/4 and focusing a few feet in front of the subject, at seven feet. On autofocus, the camera will not allow you to focus in front of the subject, only on the subject or beyond. You will have to switch over to manual focus to control your depth of field.

Finally, when shooting action photos, autofocus will never be faster than using manual pre-focus. It is always to your advantage to pre-focus a specific area and wait for the action to come into that area rather than trying to follow the action while in the autofocus mode.

> **DEPTH OF FIELD**
>
> Area of sharpness in front of and behind the subject on which you are focused.

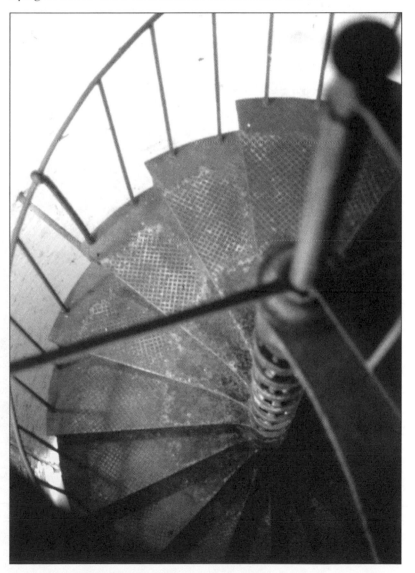

This 28mm shot of stairs in a lighthouse shows how you can isolate an area of a scene by controlling the depth of field with an autofocus lens set on manual focus. The top of the stairs are blurred, but the lower middle section is in sharp focus due to a shallow depth of field and selective focus. This shot was taken with a Tokina 28-70mm f/2.6-2.8 zoom with no filter.

CHAPTER 3

Choosing a Wide-Angle Lens

Photographing Different Subjects

"...USED WHEN TAKING PICTURES OF MANY PEOPLE TOGETHER."

Wide-angle lenses are often used when taking pictures of many people together. Because wide-angle lenses record more of an area when shooting large groups of people, they allow you to move in close and still get everyone in the shot, ensuring that people in the shot will not diminish in size. If you used a lens with a longer focal length, you would have to move back to get everyone in the shot and they would appear smaller in size. Just be aware that with ultrawide-angle lenses, the edges of a photo tend to stretch out. With a 50mm lens, you would not be able to record the entire subject at such a close range.

Using a wide-angle lens is a great way to photograph groups of people. This photo was taken with a Tokina 28-70mm wide-angle zoom f/2.8-4.5 lens at the 28mm setting.

Also, when working in tight locations with no room to move back, wide-angle lenses will fit all of the subjects in the shot. Be aware that objects close to the lens will elongate and objects at the frame edges

will stretch out. This might distort doorways or windows in an interior shot. A perspective control lens, which is a specialized wide-angle, can make corrections to minimize distortion when shooting interiors, or when photographing the exteriors of tall buildings.

Isolating Your Subject from the Background

Because wide and ultrawide-angle lenses can focus close and have a very narrow depth of field, you will have to use a little more effort in order to separate your subject from the background to create a sense of perspective in a scene.

Wide-angle lenses also incorporate many elements into a scene which can create a cluttered, busy picture. Therefore, you will also need to be a little more creative when it comes to eliminating unwanted elements from a scene.

The easiest way to isolate the main subject from the background and eliminate clutter is to shorten the distance between your camera and the subject. You can do this simply by moving closer to the subject and shooting the photograph from a low position. If you also use a larger aperture, you will produce a shallow depth of field which will make the subject appear larger and more pronounced, separating it from the background.

Any clutter from the surrounding area will be cropped out of the frame, or hidden by the main subject. Either way, you will still retain a good deal of background for interest.

The other advantage to shooting close and low is that it causes foreground lines to converge toward the subject and elongate toward the lens. This helps draw a viewer's eye to the photo and into the center of interest.

This effect is much easier to achieve with a wide-angle rather than a 50mm because a 50mm would not capture leading foreground lines and would not be capable of focusing so close to the subject while maintaining much of the background area.

Distortion

You can also use the distortion produced by some wide-angle lenses to produce great effects. Distortion is at a maximum with *curvilinear wide-angle lenses* and circular and full frame fisheyes.

The two most common types of image distortion are "pincushion" and "barrel". When pincushion distortion occurs, straight lines bow in towards the middle of the frame. With barrel distortion, straight lines bow out to the frame edges. Barrel distortion is commonly found in fisheye lenses.

There is still some distortion with ultrawide-angle lenses, but it is not as pronounced as it is with fisheye lenses. With ultrawide-angle lenses, shooting a vertical from a low position produces a long exaggerated foreground. This enhances your composition by adding an extra element to the scene. For best results with fisheyes and ultrawide-angle lenses, use strong foreground elements to attract the viewer's eye.

CURVILINEAR WIDE-ANGLE LENS

A wide-angle lens that produces image distortion by bending or curving straight lines in an image.

THE TWO MOST COMMON TYPES OF IMAGE DISTORTION:

• Pincushion

• Barrel

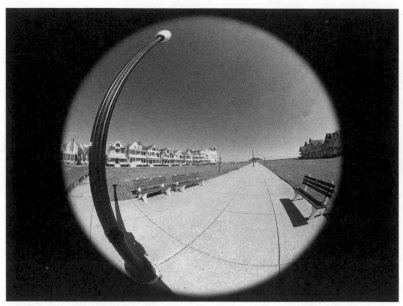

This photo shows an example of barrel distortion. The straight lines bend in at an extreme angle when placed at the edge of the frame.

Shooting a horizontal from a low angle and tilting up toward the sky with a wide or ultrawide-angle lens can increase the expanse of sky and clouds and create more interest in your photograph without curving or bending straight lines.

With a full frame fisheye lens, you can use the strong distortion to bend and curve straight lines. The horizon line will either bend up or

This photo shows an example of pincushion distortion. The center of the house bows out.

down depending on which way you tilt the camera. Tilt it up and the horizon line will bend up or tilt down and the horizon line will curve down.

If the horizon line is kept in the middle of the frame and the camera remains parallel to the scene, the horizon line will not bend at all. Using a fisheye lens can add interest to an uninteresting subject by integrating the distortion into the photograph.

Using Flash Units

Illuminating an area with a flash is somewhat more difficult when using ultrawide-angle lenses, as most flash units can't illuminate very wide areas. You could move in closer to the subject, but that might increase image distortion, and even though the flash would illuminate most of the subject, the frame edges would still be underexposed. For better flash exposures, use a flash unit that provides ultrawide-angle coverage.

Another option is to substitute a wide-angle lens for the ultrawide-angle lens and use a flash unit with wide-angle coverage while staying far enough from the subject to minimize distortion.

Using Tripods

Because a fisheye lens has the ability to record a 180° field of view, you must be aware that your fingers, feet, or camera strap may end up being part of the photograph you shoot! Always look carefully at every shot you compose to make sure there are no unwanted elements appearing in the viewfinder.

Also, when the camera is mounted on a tripod, the lens will probably record the tripod legs in the shot. To avoid this problem, use a monopod or a Benbo tripod. The Benbo allows individual positioning of the legs and center column so you can place them away from the viewing area of the lens.

Using Filters

Usually filters can't be used in front of fisheye lenses because the front lens element is so large (especially circular fisheyes), and also because the lens would see the edges of the filter mount due to its extremely wide angle of view. In many cases, lens hoods can't be used for the same reasons. When the lens records the filter mount or lens hood, the corners of the image will darken.

This effect is known as *vignetting*. You can check to see if this occurs by stopping the lens down to the smallest aperture and engaging the depth of field preview button on your camera (Some cameras do not have this feature). If your camera does not offer 100% viewing, it may be difficult to determine if vignetting is occurring until your film is processed and you can make a visual inspection.

"ALWAYS LOOK CAREFULLY AT EVERY SHOT YOU COMPOSE..."

VIGNETTING

The darkening of the image corners that usually occurs when a wide-angle or fisheye lens records the lens hood or filter mount.

This is an example of vignetting caused by the lens recording the edges of the filter mount. The shot was taken with a Sigma 18-35mm f/3.5-4.5 wide-angle zoom, set at 18mm.

Light Flare

An obstacle to overcome when using a circular fisheye is light flare caused by the sun. Because of the tremendous field of view provided by the lens, the sun will usually end up in the shot unless you can somehow block it out by placing a tree, building, or other object in front of it. The alternative is to make sure you shoot at a time of day that will place the sun in front of your subject and directly behind you.

The compromise is that even though the sun won't cause light flare, or end up in the shot, your shadow most likely will record unless you can block it out or blend it into existing shadows cast by nearby objects. Because of sun reflection, you must also keep the lens clean and free of moisture or lens flare will appear. Lens flare, caused by strong sunlight or other light sources, can also be a problem when using ultrawide-angle lenses. It can either be direct light or light reflected from a window, water, or metallic object.

Reducing Lens Flare

The best way to eliminate this problem is to block the source of the light creating the flare. This can be done by making use of a lens hood, but because they are sometimes not large enough to block out strong light, it is preferable to use an object in the scene to obscure the flare. The other choice is to place yourself out of the way of the light source by moving a short distance to either side of the light until the flare is eliminated from the view of the lens. With ultrawide-angle lenses, the sun won't always be recorded in the shot, so if it is possible, keep the sun behind you and also try to avoid reflected light from windows, water, etc. Use of a smaller aperture will also help reduce flare.

REDUCING LENS FLARE:

• Block the source of light

• Keep the sun behind you

• Avoid light from windows, water, etc.

• Use a smaller aperture

Metering for the Correct Exposure

Because of the short focal length of wide-angle lenses, metering for the correct exposure with certain subjects can be tricky. These lenses see much more than a lens with a longer focal length. Because of this, the image size is reduced, and there are no large defined areas of light and dark from which the meter can calculate a correct exposure.

For example, let's say you are shooting a scene where there is a light foreground and a dark middle ground area that bleeds into an even darker background. Your exposure meter will record what it sees the most of (in this case, the light foreground area) and will underexpose the middle ground and background. A lens with a longer focal length (narrow angle of view) provides more middle and background area and less foreground for the meter to read, producing the correct exposure for those areas.

To make an accurate exposure when using wide-angle lenses, adjust the f/stops to provide a wider range of tone throughout the entire photograph. You can do this by bracketing your exposures. This is especially useful when shooting with extreme ultrawide-angle lenses (13mm, 14mm, 16mm) and fisheyes.

For example, if you use a shutter speed of 1/125 second and the exposure meter determines f/11 as the correct aperture, shoot at that exposure. Then, take another shot at one stop over (f/8) and a third at one stop under (f/16). This will assure that one of those shots will produce a print with a balanced exposure between the bright and dark areas of the scene.

A circular fisheye lens, when mounted on most cameras, will usually block out exposure meter readouts in the viewfinder. This occurs because the lens cuts out backlighting that would normally illuminate this information. The best advice is to shoot in the program or auto (f/stop priority mode). This will allow the camera to choose both shutter speed and f/stop (program) or shutter speed only (auto), after you have selected the f/stop.

In either mode, you will not know the shutter speed the camera has chosen. On the auto setting, you will have to decide on an f/stop that you believe will allow the camera to choose a fast shutter speed. A wide aperture will cause the camera to choose a faster shutter speed. This will permit you to handhold the camera without camera shake.

Lens Cost

The cost of wide-angle and ultrawide-angle lenses range from about $350.00 to lenses costing well into the thousands of dollars. The brand name lenses and lenses with a fast speed are usually higher priced. You should shop around and compare brands and prices before you make your purchase. Remember, the tools of photography are very important and are worth the investment if they help you to become a better, more versatile photographer.

> **"...CORRECT EXPOSURE WITH CERTAIN SUBJECTS CAN BE TRICKY."**

CHAPTER 4

The Right Wide-Angle Lens for You

Why Use a Wide-Angle Lens?

When choosing the wide-angle lens that is most appropriate for you, a great deal depends on the type of photographs you take. If you shoot landscapes, architecture, interiors, groups of people, or travel photos, a wide-angle lens is a necessity. If your objective is to capture a much wider area on film, maybe a 24mm or 28mm wide-angle is for you. If you need to greatly increase your field of view and record sweeping vistas in landscape or travel photography, consider using an 18mm or 20mm ultrawide-angle lens. An ultrawide-angle 20mm or wide-angle 24mm are great lenses to use for shooting interiors in tight spaces. They greatly increase the interior area that you can record over that of a 35mm or even a 28mm lens.

The 20mm-35mm or 24mm-40mm zooms are ideal wide-angle to use for many situations from scenic vistas to interiors. You can really get hooked on using these lenses and might decide to go really wild and wide by using a circular or full frame fisheye lens with a 180° angle of view for maximum image coverage to produce the highest degrees of distortion and most startling effects. There is no limit to the choice of lenses or the images you can create when you use them.

A good idea would be to try the lens out before you make your purchase. Try to locate a photo store, library, or school that rents out lenses so you can make a more informed decision as to which wide-angle or ultrawide-angle lens best suits your needs.

Focal Length

Focal length is a very important factor to consider when choosing a lens as it determines how much of an area will be captured on film and how the objects in that area will appear in relationship to each other. Wide-angles and ultrawide-angle lenses have a short focal length which gives them a wide angle of view, allowing them to record more of an area.

For example, a 15mm ultrawide-angle lens has an impressive 110° angle of view. A longer focal length decreases the angle of view of a lens. Because of a longer focal length and narrow angle of view, a

> "YOU CAN REALLY GET HOOKED ON USING THESE LENSES..."

telephoto lens (100mm-200mm) records less of an area. It magnifies and compresses the field of view so that the appearance of space between the subject and background is diminished.

For example, a subject shot with a 100mm lens will appear four times as large in the frame compared to the same subject shot with a 24mm lens. The ability of a wide-angle lens to reduce the size of certain objects in the middle of a scene, and especially in distant areas, helps to create a more wide open panoramic look. A shorter focal length also increases depth of field, ensuring sharpness and detail near and far in a scene.

Perspective Control Lens

Another type of wide-angle lens to consider is the PC or perspective control lens. This lens is used primarily in architectural, landscape, and interior photography. It allows you to create a balanced composition without tilting the camera and corrects converging lines in a scene. The front of the lens rotates, but stays parallel to the film plane when it moves. It also allows you to raise or lower the lens barrel, or shift it sideways left or right. The combination of the shift and rotation provides a wide variety of adjustments, prevents horizontal or vertical lines from distorting, and also increases the angle of view.

For example, when a 28mm PC lens is not shifted, it has a 74° angle of view. When fully shifted, it increases to 92°, which is the same coverage you would get from a 24mm lens. When horizontal, a 28mm lens can shift a maximum of 8mm and when vertical, the shift is at 11mm.

These are the maximum permissible shifts you can use without distortion or vignetting occurring. PC lenses are usually slower than conventional wide-angle lenses and they are equipped with manual apertures. You must move the aperture ring all the way open to compose and focus, then close it down to take the shot. You must also take your exposure reading before you shift the lens to get the correct exposure.

THE PERSPECTIVE CONTROL LENS IS USED PRIMARILY IN:

- Architectural photography

- Landscape photography

- Interior photography

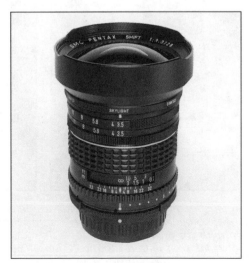

Pentax SMCP 28mm f/3.5 Perspective Shift Lens.

"WITH THE PC LENS, YOU CAN SHIFT THE FRONT OF THE LENS UP WITHOUT HAVING TO TILT THE CAMERA UP."

Example of a Shooting Situation Using a PC Lens

Here is an example of a shooting situation where you would benefit from using a PC lens. Let's say you want to make a vertical photograph of a tall building. If you use a conventional wide-angle lens and keep the camera level to the subject, you will cut off the top of the building.

If you tilt the camera up to fit in the top of the building, it will no longer be parallel to the building. This will cause the near areas to appear larger than areas farther away, and the vertical lines at the top of the building will converge. This convergence will make the building look as if it were falling or leaning back.

With the PC lens, you can shift the front of the lens up without having to tilt the camera up. This keeps the film plane parallel to the building and you can now fit the entire building in from top to bottom with no converging lines or distortion. The building will no longer appear to be falling but will stand straight. Always mount your camera on a tripod when using PC lenses.

Left: *This photo was taken with a 28mm wide-angle lens. Note the converging lines causing the structure to appear to be leaning back. The 28mm lens used was a Sigma 18-35mm zoom f/3.5-4.5 set at 28mm with an orange filter.*
Right: *This photo was shot with a 28mm PC lens. The lines of the structure are now straight and it no longer appears to be falling. The PC lens used was a Nikon 28mm f/3.5 with an orange filter. (Photo by Andre Grastyan)*

Having the capability to shift the lens allows you to photograph around an object that can't be moved, such as a tree, when you can't change the position of the camera. You just shift the interfering object out of the view of the lens. Also, if there is an object near the camera that you want to include in the shot without moving the camera, just shift the lens to bring it in. A viewing screen with imprinted grid lines will aid with composition by keeping lines straight, and everything level, in the viewfinder.

Things to Watch Out For when Using a PC Lens

There are some things to watch out for when using PC lenses. First, because light readings are sometimes not the same in the shift mode as in the non-shift mode, you should make test exposures. (Reading for the test exposures should be made in both shift and non-shift modes.) Also, vignetting may occur if the movement of the camera does not keep within the limits of the lens coverage. Some of the newer PC lenses have filters built in which can be dialed in by an external ring, and some provide for the use of filter gels behind the lens.

Making Panoramic Photos

The shift movement can also be used to make panoramic photos. Using a viewfinder with gridlines makes it easier to accomplish. With a camera mounted on a tripod and set up for a horizontal shot, shift the lens all the way to the right and using the grid, make a note of an object at the left side of the focusing screen for a reference point. Take your shot and then move the camera and tripod to the left. Now shift the lens all the way to the left and match up the previously noted reference point to the right side of the focusing screen. Take a second shot and when prints are made, you can match up the edges because the exact film plane was maintained in both exposures.

You can also shoot two photos from the same camera position with the lens shifted to the left side for one shot, and to the right side for the second shot. The resulting prints will contain a slight overlap but will expand the field of view about 1/3 more on either side compared to a photo taken with a wide-angle lens of the same focal length. If you prefer, the resulting negatives or slides can be stripped together and printed as one photograph with either of these shooting methods. Pentax, Nikon, Canon and Schneider make PC lenses. Canon makes a 24mm, 45mm and 90mm. Nikon makes a 28mm and a 35mm. Pentax makes a 28mm lens.

Panoramic Cameras

Panoramic cameras capture an extremely wide field of view and are ideal for landscape, travel and architectural photography. They create super wide-angle images by recording a view on film that is almost twice as long as conventional film. (A 36 exposure role will produce 19 exposures with a panoramic camera.) On some panoramic cameras that use a fixed, non-rotation lens, the field of view is 80° or 90° horizontal.

PANORAMIC CAMERA

A camera that creates super wide-angle images by recording an expansive view on one long piece of film through the use of a rotating lens or camera. These cameras produce magnificent distortion-free images.

"...IDEAL FOR LANDSCAPE, TRAVEL AND ARCHITECTURAL PHOTOGRAPHY."

On other models, the lens rotates, or the camera and lens rotate together as a unit. They have a field of view of approximately 130°. When the lens rotates, the lens drum makes one rotation per exposure in a clockwise direction, employing a consistent shutter gap to create a natural perspective.

When the camera and lens rotate as one, the film travels in the opposite direction of the body rotation. On panoramic cameras, the film is stretched out over a curved tract to achieve a virtually distortion free, super wide-angle photo that looks different from those shot with a conventional wide-angle lens.

This shot was taken with a Noblex panoramic camera. These cameras create a super wide-angle image by eliminating some of the foreground and sky. (Photo by Hans-Jorg Schonherr)

Exposure Speeds

Panoramic cameras allow a wide range of exposure speeds through fast, adjustable shutter speeds. A fast exposure speed allows you to produce blur-free photographs even without a tripod.

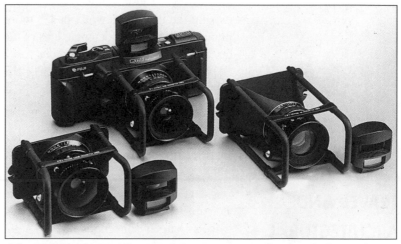

The Fuji GX617 Professional Panorama Camera with the multi-lens system.

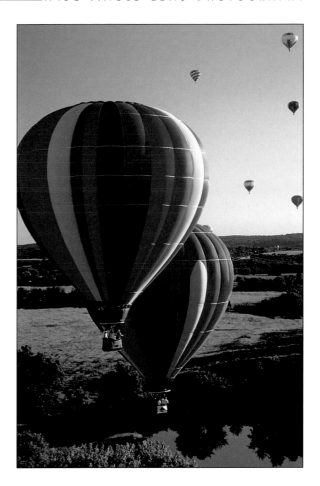

Top: *This photo was taken with a Tokina 28-70mm zoom f/2.6-2.8 lens set at 28mm, with a polarizing filter. The photo captures hot air balloons in all their beauty as they float in the late summer sky.*
Bottom: *With a 16mm fisheye lens pointed up from a low position, a swirling effect is created as the clouds and shadows on the sand and pavilion all curve at extreme angles. The lens used was a Minolta 16mm f/2.8 fisheye with a 1A filter.*

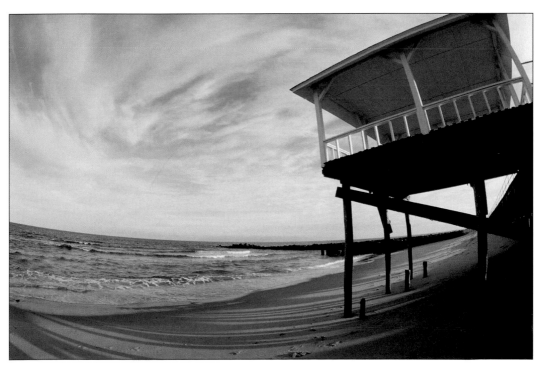

Top: *A striking southwestern still life is recorded by a Tokina 28-70mm f/2.6-2.8 zoom lens set on 28mm. A Tiffen polarizing filter was also used.*

Bottom: *The essence of an adobe building in the southwest is captured by the Tokina 28-70mm f/2.6-2.8 zoom lens. The lens was set on 30mm and a polarizing filter from Tiffen was used.*

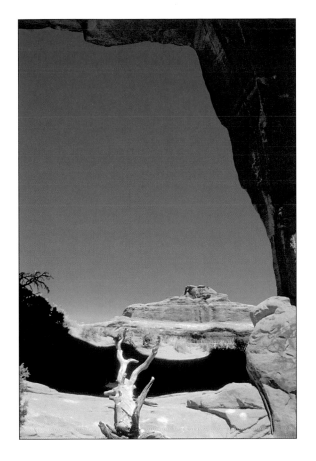

Top: *A southwestern landscape, framed by a natural arch, was taken with a Sigma 18-35mm f/3.5-4.5 zoom with a lens setting of 24mm. A Tiffen polarizing filter was used.*
Bottom: *The breathtaking beauty of the grand canyon is recorded by the Sigma 18-35mm f/3.5-4.5 zoom lens. The lens was set at 24mm and a Tiffen polarizing filter was used.*

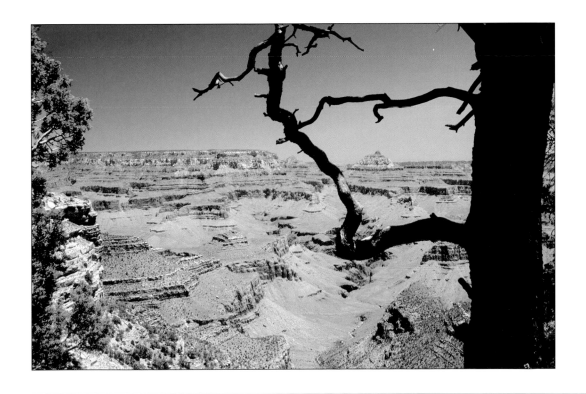

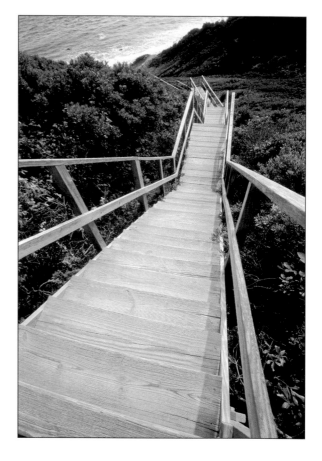

Top: *These stairs, that descend from a 150 foot cliff, seem even more perilous when shot with an 18mm lens. The photo was taken with a Sigma 18-35mm f/3.5-4.5 zoom lens.*

Bottom: *The curvature of the earth and long leading lines of the wooden pilings are due to a 16mm full frame fisheye lens pointed down from a high viewpoint. The lens used was a Minolta 16mm f/2.8 fisheye with a 1A filter.*

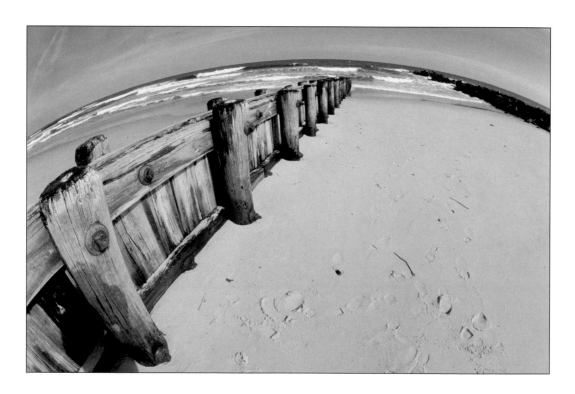

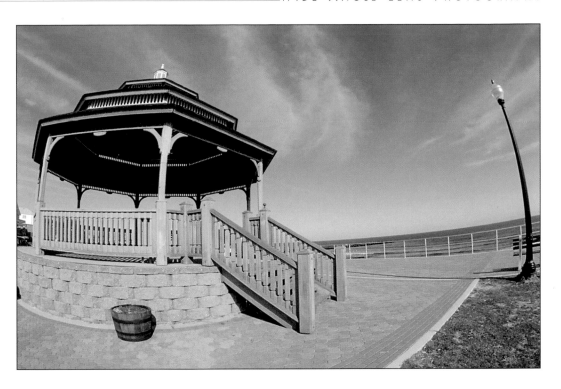

Top: *Although this large gazebo and lamppost are far apart, a 16mm full frame fisheye lens includes them both in this shot. A Minolta 16mm f/2.8 fisheye lens was used with a 1A filter.*
Bottom: *Pincushion distortion at its best causes this seascape to jump right out at the viewer. The photo was taken with a Minolta 16mm f/2.8 full frame fisheye lens and a 1A filter.*

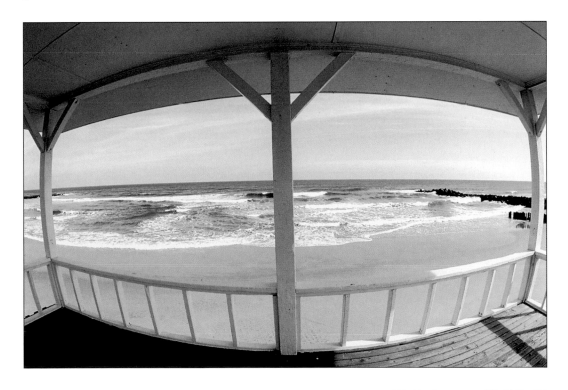

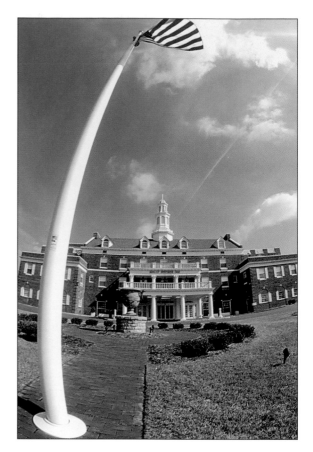

Top: *Image distortion can be used to make intriguing shots, such as this photo with the curving flagpole. A Minolta 16mm f/2.8 full frame fisheye lens was used with a 1A filter.*
Bottom: *This photo depicts an example of barrel distortion. The lens used was a Minolta 7.5 circular fisheye f/4 and a 1A filter.*

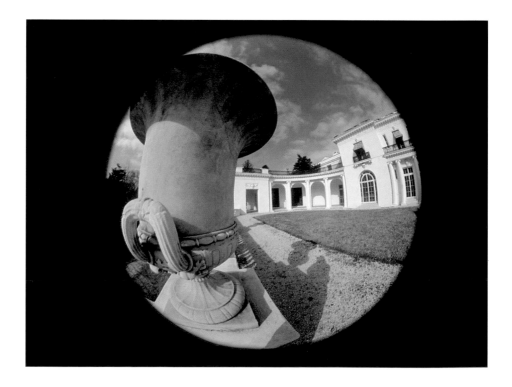

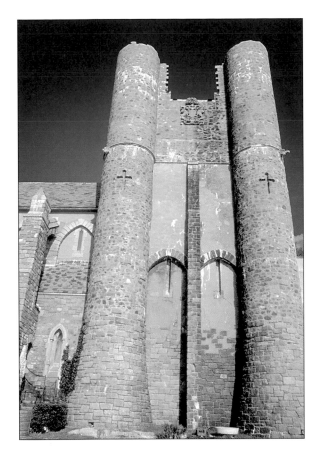

Top: *The tall walls of this castle are recorded without distortion by the Tokina 28-70mm f/2.6-2.8 zoom lens. The lens was set at 28mm and a Tiffen polarizing filter was used.* **Bottom:** *Image distortion makes the pillars of this house appear curved. In reality, these pillars are straight. The lens used was a Minolta 7.5mm circular fisheye f/4 with a 1A filter.*

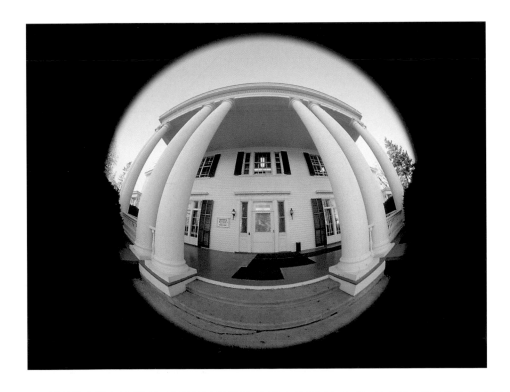

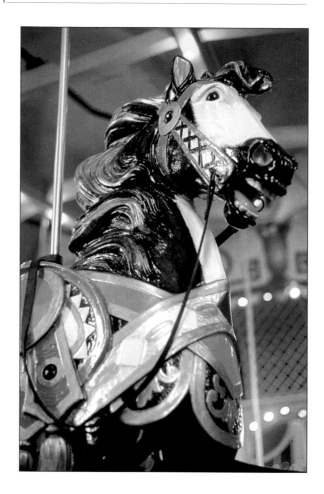

Top:: *This carousel horse seems ready to come to life when photographed from a low position using a Tokina 28-70mm f/2.6-2.8 zoom. The lens was set on 28mm using existing light and a UV filter.*
Bottom: *A beautiful sunset is captured with a Tokina 28-70mm f/2.6-2.8 zoom. The lens was set at 28mm and a polarizing filter from Tiffen was used.*

These cameras eliminate a good deal of foreground and upper sky, giving you a genuine panorama with a tremendously wide angle of view. Because these cameras record such a wide area as they scan a scene, you must make certain there is enough interest in the scene from frame edge to frame edge to make a compelling image.

Also be sure there are no unwanted elements anywhere within the entire viewing area. Finally, make sure the sun will not end up in the scene at some point during the rotation, as this will produce lens flare.

Panoramic cameras are ideal not only for landscape photography, but also for taking photographs of large groups of people. Panoramic cameras are expensive, but the resulting images are very impressive. No other camera can duplicate the wide-angle view of a panoramic camera.

Distortion

Minor distortion is inherent in panoramic cameras, so they must be positioned properly to avoid more obvious distortion. If the camera is not parallel to the subject when making a horizontal or vertical shot, vertical lines will bend as the camera or lens rotates.

When making a horizontal shot with the camera parallel to the subject, horizontal lines close to the lens will bow slightly.

When shooting a vertical with the camera level, vertical lines close to the lens will also bow slightly. This is due to the change in angle from subject to lens as the lens or camera rotates.

Interesting Effects

The rotation of the camera or lens occurs in order to capture a super-wide, sharp image on one long section of film. The advantage is that the film plane of the camera is curved which eliminates elliptical distortion at the frame edges. Panoramic cameras produce the interesting effect of elongating or compressing moving objects such as cars, bicycles, etc., as they pass across the field of view while the lens or camera is rotating. Objects that move in the same direction as the lens or camera (left to right) will elongate, while those that move in the opposite direction will be compressed. This can be due to limited shutter speed options, and the fact that the human eye is not a good judge of speed. Noblex, Widelux, Fuji and Linhof all manufacture state of the art panoramic cameras.

Point and Shoot Cameras

Many people are using 35mm point and shoot cameras that include wide-angle zoom lenses for convenience when they travel. They also use them for photographing special occasions.

These cameras are compact, lightweight and easy to operate. They usually include built-in flash, self-timers, autofocus, autoexposure, and auto film advance features, and some are water resistant.

Other features include red eye reduction and switchable panoramic format. Many newer models include one touch wide-angle zoom lenses.

"No other camera can duplicate the wide-angle view of a panoramic camera."

Canon Sure Shot 35-70mm wide-angle zoom f/4.2-7.8 "point and shoot" camera.

Kodak is one of the companies that manufactures a 35mm panoramic single use camera.

The wide range of zooms include 38-60mm, 38-105mm, 38-80mm, 38-120mm 38-140mm, 38-110mm, 28-110mm, 38-90mm, 35-70mm, and 38-70mm. Prices range from about $150-$400. Manufacturers include Nikon, Fuji, Canon, Pentax, Olympus, Minolta, Yashica, and Vivitar.

Single Use Panoramic Cameras

Another inexpensive way to shoot wide-angle photos is with the new single use panoramic cameras. They are constructed of plastic and preloaded with 35mm 400 ISO/ASA film. They usually contain 12 or 15 exposures and the prints made from the film are twice as long as standard prints. When the negative is printed by the photo lab, it is actually enlarged to an 8 x 10 print.

However, because the top and bottom third of the negative is cropped in the camera, the print becomes a 3 1/2 x 10 photo, effectively giving the illusion of a panoramic shot.

These cameras are equipped with a shutter speed of 1/100 second and use a fixed focus lens. The lenses are usually either 17mm, 24mm, or 32mm. When you finish the roll of film, the entire camera is sent to a lab for processing.

These cameras are compact, inexpensive (about $20), and easy to use. They are great for photographing vacations, birthdays and groups of people. Kodak, Fuji and Konica manufacture single use panoramic/wide-angle cameras.

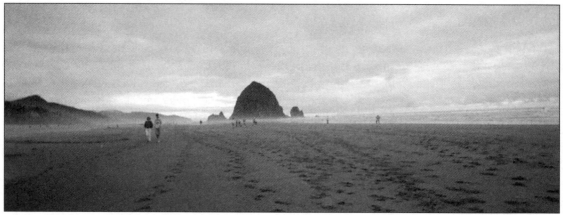

Here is an example of a photo taken of the Oregon seashore with a Kodak single use panoramic camera. Single use cameras are great for vacations and are compact, inexpensive, and easy to use. (Photo by Mary Jo Muse)

CHAPTER 5

Accessories

ACCESSORIES FOR WIDE-ANGLE LENSES:

- **Filters**
- **Lens hood**
- **Teleconverters**
- **Fisheye converters**
- **Tripod**
- **Panoramic head**
- **Flash units**

Filters

When purchasing filters for your wide-angle lenses, make sure to choose filters made from high quality optical material. Filters are available from many manufacturers in a variety of sizes and applications. Producers of filters include Tiffen, Hoya, Albinar, Soligar, Kodak, Vivitar, Tokina, Minolta, Canon, and Nikon. Special consideration is required when purchasing filters for some ultrawide-angle lenses such as those of 13, 14, 15 or 16mm.

The extreme coverage of these lenses and the large front lens element prohibit the use of front mounted filters. Most photographers use a filter gel taped to the back of the lens or use large gels held in front of the lens. Any gel placed in front of the lens, however, can cause light flare, so care must be taken. Some lens manufacturers include rear bayonet mounted filters. When using a gel behind the lens, remember to make it small enough so it does not interfere with the lens coupling on the camera.

Once you get to the less extreme ultrawide-angle lenses (18mm - 20mm), problems with lens flare are minimized and filters can be used in front of the lens, but only one at a time. Vignetting will occur if you stack filters, because the lens will see the mount on the second filter. Vignetting can also occur when stacking filters on medium-wide-angle lenses (24mm and 28mm), so it is not recommended.

For most wide-angle lenses (24mm-35mm), you can screw the filter onto the front of the lens. To determine the correct filter size, look inside the lens cap for the millimeter marking. You will most likely need to purchase a separate filter for each lens you own as it is unlikely any two lenses would have the same size front lens element.

There are special adapter accessories known as *step up* and *step down* filter rings. These rings allow you to adapt filters that are too large or too small to a particular lens. However, most wide and especially ultrawide-angle lenses would "see" the adapter ring. This would be similar to stacking filters, and it would produce vignetting which makes the use of these rings impractical.

"THIS FILTER DARKENS BLUE SKIES, SATURATES COLOR, AND REDUCES GLARE..."

POLARIZING FILTER

Used to eliminate reflections from water, windows, etc., thus greatly improving contrast and saturating color.

Tiffen's professional glass filter line.

COMMON FILTERS USED WITH BLACK AND WHITE FILM:

- Yellow
- Orange
- Red

Polarizing Filter

The filter you will probably use the most when shooting color film is a *polarizing filter*. It is set in a rotating mount that allows you to turn the filter to achieve the maximum effect, thus producing the most dramatic results. This filter darkens blue skies, saturates color, and reduces glare and reflections from surfaces such as glass and water. The effects will be most noticeable when the sun is to your side or behind you.

The two types of polarizing filters available are linear and circular. You can use a linear polarizer with manual focus lenses, but for autofocus lenses, you need to use a circular polarizer. The linear type can affect autofocus operation and cause incorrect exposures. This is due to light polarization caused by the metering and autofocus systems in most new cameras. The circular polarizer — circular denotes the way the filter polarizes light, not the shape of the filter — allows the camera's exposure meter and autofocus system to operate with accurate results.

You can also use a polarizing filter with black and white film to darken skies without affecting the tonal rendition of other colors. A UV (ultraviolet) or skylight filter can be used to reduce haze with black and white film and with color film to absorb ultraviolet rays which can produce a bluish cast to the film.

These filters also reduce reflections and protect your lens from dust, dirt, moisture and scratches. Normally, once you attach a UV or skylight filter to your lens, you can leave it in place and attach other filters to them when needed. Because you shouldn't stack filters on wide-angle lenses, it is advised that for black and white or color film you use the polarizing filter outdoors on sunny or slightly overcast days. Use the UV or skylight filter indoors with existing light or flash as the light source for correct color rendition.

You can use other filters for enhancing colors or for special effects with color film, but remove the polarizing filter to avoid vignetting or place a filter gel behind the lens if you want to use the front mounted polarizer for color saturation and glare reduction.

There are filters that are made specifically for use with black and white film for increased effects and to darken skies. You don't need to use them in combination with other filters such as the UV, skylight or polarizer. They can be used individually in place of those filters either on the front lens element or as a gel behind the lens.

Common Filters Used with Black and White Film

The most common filters used with black and white film are yellow, orange and red. A yellow filter will absorb blue and ultraviolet light to darken skies and reduce haze. An orange filter will increase contrast and darken skies and foliage. A red filter produces the highest contrast by filtering out all color except red. This causes foliage to darken and blue skies to appear almost black while rendering clouds very white. Note: When you clean your filters, use the same method and products that you use to clean your lenses.

Half-Color and Dual-Color Filters

The most popular filters used with color film to enhance or alter the look of a scene are half-color and dual-color filters. Half-color filters are set in rotating mounts. One-half of the filter contains a color gelatin and one-half is clear. Dual-color filters are also set in rotating mounts, but are divided in half using gelatins in two color combinations; for example, orange/green, yellow/purple, red/blue.

Built-In Filters

Most fisheye and some ultrawide-angle lenses have filters built in. You access them by turning an external ring to dial them in place. The most common built-in filters are an 0-56 (orange), Y-48 (yellow), L-1A (skylight), and FL-D (to color correct daylight film when used under fluorescent lights). A polarizing filter is usually not incorporated. This is because it could not cover a 180° area with a fisheye lens or an extremely wide angle of view (from 94° - 118°) with ultrawide-angle lenses and still produce an even exposure across the entire frame. Most of the built-in filters are for use with black and white film; some are used with color films for color correction or enhancement.

Lens Hood

An essential accessory that is especially useful with wide-angle and ultrawide-angle lenses is a *lens hood*. Lens hoods help to prevent lens flare, reduce stray light, and eliminate vignetting. Lens hoods made from hard materials also protect your lens from damage should you drop or hit the lens against a hard surface. Some lens hoods snap on, screw on, or slip over the lens using retainer rings. You can also purchase lens hoods constructed of rubber that fold back over the lens barrel when not in use, but they are too soft to offer any shock protection for the lens.

When you purchase a lens hood, make sure it is a hood made specifically for a wide-angle lens rather than a standard lens. Vignetting may occur if you don't use the correct type of hood. Some ultrawide-angle lenses are equipped with special lens hoods that are built in or detachable.

Teleconverters

A teleconverter is a piece of optical equipment used to increase the focal length of a lens. For example, a 2x converter will double the focal length of a lens (20mm becomes 40mm, 40mm becomes 80mm). Because you are adding another glass element between the camera and lens, there is a loss of image quality. Converters slow down the speed (f/stop) of a lens and decrease the depth of field. A 2x converter would effectively change an f/stop of 2.8 to an f/stop of 5.6! An increased or longer focal length also means a narrowing of the angle of view.

Teleconverters are geared more toward standard and telephoto lenses as an inexpensive way to increase the power of the lens. However,

Minolta's AF 16mm f/2.8 fisheye lens with attatched metal lens hood

LENS HOOD

Accessory that attaches to the front of the lens to reduce stray light, minimize flare and improve contrast and color saturation. Hard plastic and metal hoods offer shock protection for the lens.

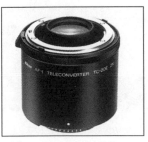

Nikon TC-20E AF-I Teleconverter (2x)

they can be used on wide-angle lenses to quickly increase the lens to a longer focal length wide, or even a short focal length telephoto lens. (24mm becomes 48, 28mm becomes 56mm, 35mm becomes 70mm, etc., when using a 2x converter.)

Fisheye Converter

Because there may be only a limited number of shooting situations in which you would use a circular fisheye lens, an inexpensive option to consider is a fisheye converter. This is an auxiliary lens that produces a 180° angle of view, curving straight lines and creating extreme distortion. It is inexpensive and can be used with various focal length lenses (from 30mm-200mm). The effective aperture of the fisheye converter depends upon the focal length of the lens with which it is used.

For example, f/5.6 is the maximum aperture when used with any 50mm lens. The converter multiplies the focal length of the lens to which it is attached. (50mm becomes a 7.5mm, 30mm becomes a 4.5mm.) Adapter rings can be used to attach the converter to a variety of lenses. The quality is quite good considering the price, but not as good as the more expensive "true" fisheye. There is a slight softness at the edges of the image, but it is not offensive. This is a less costly way to help you decide if you like the effects the fisheye produces and how often you might use such a lens.

If after using the converter you decide that you can afford and make good use of a circular fisheye lens, then you can step up to a true fisheye. This will add another versatile tool to your photographic bag of tricks. This lens is great fun to use and very addicting.

> **"THE QUALITY IS QUITE GOOD, CONSIDERING THE PRICE."**

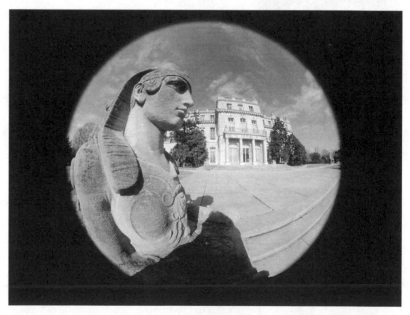

This photograph was taken with a Spiratone fisheye converter.

Tripod

Another invaluable piece of equipment for use with wide-angle lenses, PC lenses, or any lens for that matter, is a sturdy tripod. A tripod is needed for a variety of shooting styles and techniques including landscape, panoramic, interior, architectural, portrait, slow shutter, and time exposure photography. One feature to look for is a quick release mounting plate attachment. This allows you to quickly and easily remove the plate from the tripod, fasten it directly to the camera, and set the camera into the tripod head. This provides better support for the camera and eliminates the need to struggle with the camera while attempting to attach it to a stationary screw set in the tripod head.

Other Tripod Features

Other helpful features on a tripod include a bubble level to help keep vertical and horizontal lines straight, and a reversing center column to allow you to shoot from a low position near the ground. Another great feature is a multiple position head or ball head which allows for smooth, easy camera position adjustments. A ball head is especially useful in providing fast, multidirectional camera movements that include swings, tilts, horizontals, and verticals. There are many well-made tripods on the market that are solid, sturdy, and lightweight. Some of the manufacturers include Bogen, Gitzo, and Slik. As mentioned earlier, if you use fisheye lenses, you will need a monopod or specialized tripod. The Benbo tripod from Saunders allows you to position each leg and the center column individually so they will not be recorded by the lens. When your camera is tripod mounted and you want to trip the shutter, use a cable release to avoid touching the camera and causing it to shake. A cable release is an accessory that provides off-camera shutter operation. The cable release screws into the shutter button. On some newer cameras, it attaches to the camera body. They are an inexpensive yet very valuable accessory.

Panoramic Head Accessory

A great piece of equipment for matching-up a series of photos to create a panoramic look is a panoramic head accessory. It mounts between the camera and tripod to provide panoramic shooting when using wide-angle or longer focal length lenses (28 - 105mm). A good unit (such as the one manufactured by Nikon) includes a bubble level, calibrated lens markings, and notched interval lens stops.

The panoramic head allows the correct amount of image overlap for a more precise match-up of the photo edges when making multiple continuous images of a scene. You simply take one shot, turn the camera left or right to the notched lens stop for the lens you are using, then take another shot and so on. You can continue rotating the camera as many times as it takes to create as much of a panorama as you desire. You will then have a series of photos with edges you can trim, align, and mount side by side.

"ONE FEATURE TO LOOK FOR IS A QUICK RELEASE MOUNTING PLATE ATTACHMENT."

A Benbo tripod is a versatile tool when using wide-angle or fisheye lenses.

"LOOK FOR A FLASH UNIT THAT PROVIDES WIDE-ANGLE COVERAGE."

This Vivitar 285HV Zoom Thyristor flash unit covers a wide-angle of 28mm and 35mm. It also covers wide-angle zooms of 28-70mm, 28-80mm, 28-105mm, 35-70mm, 35-80mm and 35-105mm.

Flash Units

Electronic flash units are a must for indoor photography, especially when shooting interiors with a wide-angle lens. Look for a flash unit that provides wide-angle or ultrawide-angle coverage for fixed focus lenses from 18-35mm. Some flash units also produce coverage for a range of wide-angle zooms such as 24-70mm, 28-70mm, 28-80mm, 28-105mm, 35-70mm, and 35-105mm. Ultrawide-angle zoom coverage is also available from many flash units; for example, 18-35mm, 20-40mm, 24-50mm, and 24-70mm. You may also consider a flash unit that offers an optional wide-angle flash adapter to provide the necessary coverage. Other factors to consider are units that provide plenty of power and have a fast flash recycling time. Optional features to consider include red eye reduction, tilt, or tilt and swivel head options for bounce flash capability. These features provide softer, more natural lighting and also eliminate harsh background shadows.

Dedicated or Dedicated/TTL Flash

Also when choosing a flash, it is to your advantage to decide if you want a dedicated or dedicated/TTL unit. A dedicated or dedicated TTL flash used with some dedicated cameras will automatically set the shutter speed for proper flash sync. With cameras equipped with a programmed auto-exposure mode, it will also set the aperture or allow you to focus on a subject in flash range and select any aperture that falls within that range. A dedicated/TTL flash unit used in conjunction with a camera equipped with a TTL flash-metering system and programmed autoflash mode will automatically determine the correct shutter speed, aperture, and subject distance to provide the proper amount of flash needed for a correct exposure. All you have to do is compose, focus on a subject within flash range, and shoot. With through-the-lens flash metering or TTL, a cell located in the mirror compartment of the camera measures through the lens light reflected from the film during flash exposure. This system allows you to make extremely accurate exposures when taking flash photographs.

Sync Cord

A worthwhile accessory for flash operation is a sync cord which will enable you to remove the flash unit from the camera for off-camera operation to provide better control over lighting angle and position. They are available in straight or coiled cords at various lengths. Manufacturers of electronic flash units include Nikon, Canon, Minolta, Sunpak, Vivitar, and Achiever.

CHAPTER 6
General Shooting Tips

Balanced Composition

The biggest challenge most photographers face when using a wide or ultrawide-angle lens for the first time is achieving a balanced composition. You have to re-think the way you compose a picture because the large angle of view adds many more elements to a photograph. This can make for a very busy photo, and may cause the main subject to get lost amongst the other elements in the shot. When composing a shot remember that wide-angle lenses make objects that are close look even larger than they are. They also make objects far away look smaller. Shooting at eye level with wide-angle lenses makes for uninteresting photos.

Shoot close for more interesting photographs, using elements in a scene to create depth. You can use objects such as leading lines which include walls, trails, fences, roads, etc., to add interest to your photos. Leading lines start out in the foreground and extend to the horizon and will contribute to the feeling of depth. These lines seem to stretch farther out into the distance to create more perspective. To enhance this effect, put the start of the leading line off to the side of the frame and have it extend out to the main subject.

Getting Close to Your Subject

The main rule to follow when composing a shot with a wide-angle lens is to get physically close to your subject. When we view a scene, we see it much differently than the way the lens sees it because we don't possess the peripheral vision of a wide-angle lens. Our brain actually eliminates clutter and isolates singular sections of a scene, making it seem more distinct and closer to us than it does to the lens.

Moving physically closer to the subject increases the size of the subject's image on film and will also alter the subject's size relative to the other objects in a scene (perspective). There are two ways to alter the size of your subject in a scene. One way is to move closer to the subject to make it appear large, relative to more distant objects. Or, you might move further away to make it look small. A way to alter subject size without moving or changing perspective is to use a lens with a

"THE MAIN RULE...GET CLOSE TO YOUR SUBJECT."

longer focal length to make your subject look larger. Or, use a shorter focal length lens to make the subject appear smaller.

For example, background objects will appear smaller using an 18mm lens than if you move back and shoot the same image using a 35mm lens. Switching to a longer focal length lens increases the size of all objects in a scene equally without changing the perspective. Moving closer expands perspective and moving away compresses it, so you can decide on your subject-to-camera distance to control perspective. You can then use a particular focal length that will cover the area of the scene that you wish to capture.

Distorting an Image

If you want to greatly distort an image and make it obvious that it was photographed with a fisheye lens, get close to your subject and either tilt the camera up from a low position or tilt down from a high viewpoint. The closer you get, the more the subject will protrude outward, producing a bulbous, convex effect.

With either a full frame or circular fisheye lens, any straight horizontal lines that are above or below the dead center of the frame will bend or curve to create an elliptical look. Vertical lines that are not directly in the center of the frame will bow outward toward the frame edges. These effects are more pronounced with a circular fisheye lens as it has greater curvature due to a more extreme angle of view and shorter focal length.

You need not shoot only circular objects with a circular fisheye lens, because the curvature of the lens will produce a spherical appearance to the objects that you photograph. You can, however, incorporate the curvilinear design of the lens when shooting rounded structures such as stadiums, rotundas, carousels, ferris wheels, etc., to enhance their spherical shapes.

When shooting with a *full frame fisheye lens*, circular objects will become more oval in appearance. How pronounced most of these effects will be depends upon the camera-to-subject distance and the difference between the film plane and subject plane.

If you want to minimize the fisheye effect, eliminate any vertical lines near the edges of the frame and place any straight lines directly in the center of the frame. When straight lines are in the center of the frame, they will not bend, but stay relatively straight.

Large Groups of People

When photographing large groups of people, try to photograph from the waist up, if possible, and not from head to toe. This will keep the faces more prominent and recognizable. Make an effort to break up the straight-line of heads and also close up spaces between the people in the group. Move as close as you can without distorting the edges of the frame and move the whole group close together. Make sure no one is blocked out by another person. Try to get everyone to relax, have fun and keep their eyes open!

FULL FRAME FISHEYE LENS

A wide-angle lens with a 180° angle of view that bends and distorts straight lines across the entire width of the image area.

"...GET EVERYONE TO RELAX...AND KEEP THEIR EYES OPEN!"

To change perspective, but maintain a constant image size for a selected subject, change focal length and distance simultaneously. With the image above, an 18mm lens was used close to the foreground. With the image below, a 35mm lens was used farther away from the foreground. Notice that the foreground objects remain the same size, but the background size changes. The lens used for both shots was a Sigma 18-35 f/3.5-4.5 zoom with an orange filter.

Using Props

To give a group shot a little more interest, try using some kind of prop. For example, if you are shooting a baseball team, use some bats, gloves, etc., to make the shot more interesting. This works well with the extra space a wide-angle lens usually provides. When shooting a line of people, if you are up toward the front of the line, a medium-wide-angle lens will allow you to isolate the people closer to you and still include the people farther away.

Action Shots

For action shots, just remember, if you want to freeze action and retain sharp detail in your subject, use a fast shutter speed (1/125 or faster). Depth of field is sharp with wide-angle lenses so you can use a wider aperture to let more light in to compensate for the faster shutter speed. This will not sacrifice sharpness. Try not to use too wide an aperture or sharpness will diminish somewhat. Overall, depth of field will remain quite sharp, especially when compared to other lenses used under the same conditions. Get close to your subjects and keep the camera level.

> **TO FREEZE ACTION AND RETAIN SHARP DETAIL ON YOUR SUBJECT:**
>
> • Use a fast shutter speed
>
> • Get as close to your subject as possible
>
> • Keep the camera level

This shot was made using a fast shutter speed of 1/250 sec. to freeze action while retaining sharp detail on the subjects. Be sure to keep the camera level and try to get as close to your subject as possible. The lens used was a Sigma 18-35mm f/3.5-4.5 zoom, set at 20mm with an orange filter.

This shot was made using a slow shutter speed of 1/30 sec to emphasize motion. A Sigma 18-35mm f/3.5-4.5 zoom lens was used, with a lens setting of 20mm and an orange filter.

TO EMPHASIZE MOTION BY BLURRING YOUR SUBJECT:

- Use a small aperture
- Use a slow shutter speed
- Use a tripod

"...HELPS ESTABLISH A MORE HEIGHTENED FEELING OF MOTION"

If you want to how linear movement and emphasize motion by blurring the subject, use a small aperture and slow shutter speed, ideally with the camera mounted on a tripod for added stability. Use a shutter speed of 1/30 second or slower. For more impact, open the shutter just as the subject enters from either side of the view-finder. Use a slow enough shutter speed to allow the subject to proceed about 3/4 of the way into the frame. This will leave 1/4 of the frame without the subject, (negative space) which will increase the sense of forward motion. This, together with the leading lines created by the blurred action, help bring a viewer's eye into the scene.

The combination of a slow shutter speed and the sharp depth of field of a wide-angle lens helps establish a more heightened feeling of motion by keeping the background in sharp focus while the subject blurs against it.

The advantages of using a wide-angle lens include: the sharp depth of field, the ability to use a wide aperture, and using a fast shutter speed. These advantages make the wide-angle lens ideal for action shots. The wide angle of view also helps minimize blur because the movements of a subject are not exaggerated as they would be from the narrow angle of view (high magnification) that would occur from using a telephoto lens. Also, when shooting sports action such as basketball, baseball, etc., where the action is played out on a wide field, a wide lens will allow you to capture a large area of action.

Telephoto Lens

A telephoto lens with its very narrow field of view restricts what you shoot to only portions of the playing area, limiting the view of the

action. The drawback with wide-angle lenses is that they can only be used when you can get very close to the action. Even though you can capture more of the action, in order for it to have any impact, you must be right on top of things.

Telephoto lenses are better suited to shooting action when you are at a distance because they bring everything in close. However, because of the high magnification, it is necessary to use a very fast shutter speed to freeze the action and eliminate camera shake. To allow for a faster shutter speed, you need a wide aperture to let in more light. This causes a shallow depth of field that will make the subject stand out, but will render the background out of focus.

Telephoto lenses are also difficult to handhold and keep steady, especially when moving the camera to follow the action. It is also a challenge following a subject with a telephoto lens as the subject may move right out of frame by traveling only a short distance. All movements, either by the subject or photographer, seem exaggerated due to the increased magnification.

The best compromise incorporates the wide-angle and telephoto capabilities found in a wide-angle zoom lens such as the 28-200mm. This lens would be ideal for just about any action scenario. It allows you to have many different lenses from which to choose. Whether you are close to the action or far away, you will be able to conveniently select the correct lens for the situation.

Try to use a tripod and cable release to eliminate camera shake. Shooting with fast film will allow the use of fast shutter speeds and small apertures to achieve the best results.

Shooting tip: For better action shots, pre-focus your lens at a specific area in the field of action and wait for the subject to arrive at that area to make the shot. This way, you don't have to follow the subject and constantly adjust your focus.

Still Life Photos

Photographing a still life is a good way to improve your skills in composition and visualization. Simply put, a still life is an arrangement of inanimate objects that can be found naturally or set up by the photographer.

You can find natural still lifes in most outdoor settings. Some examples are shells and driftwood on the beach, rows of colorful beach umbrellas, or rocking chairs sitting on a porch. Look for interesting and distinct shapes, strong color, and the interplay of light and shadow. Use a number of different wide-angle lenses to vary the look of the still life (35mm, 28mm, 24mm). Also, try shooting at various camera angles and positions for more interesting results. The best thing about shooting a still life with a wide-angle lens is that you can get very close and still include many objects in your shot.

Remember to balance the composition of the many elements and don't be afraid to distort lines or alter perspective to create a photograph with impact.

FOR BETTER ACTION SHOTS:

- Pre-focus your lens at a specific area

- Wait for the subject to arrive at that area

"...TRY SHOOTING AT VARIOUS CAMERA ANGLES AND POSITIONS..."

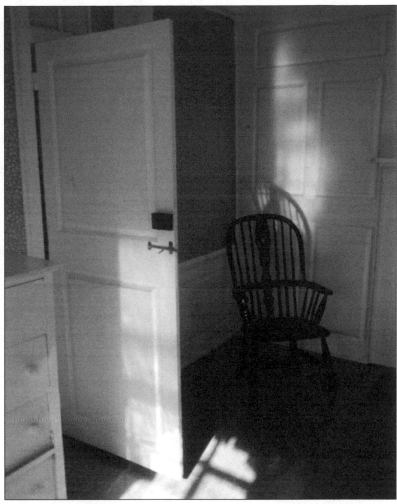

This interior photo was taken with a 28mm lens using the existing light. The open door and chair help to add interest to the shot.

Photographing Interiors

"...FIRST DECIDE WHERE YOUR CAMERA VIEWPOINT WILL BE."

When photographing interiors, first decide where your camera viewpoint will be. You might choose more than one viewpoint to add more interest to the shot and to achieve several different looks. Find one or several elements in the room that offer a strong visual impact. To give a more spacious feeling to a room, use a wide enough lens to include as much of the room as possible. Before shooting, take a final look through the viewfinder to make sure there are no unwanted elements in the shot. It will also help you visualize the final image.

Flash Units

When using a flash for interiors or indoor group shots, use a flash unit with wide-angle coverage. Some flash units can cover from 35mm to 28mm, and others cover from 35mm to 24mm lenses. With the addition of a wide-angle flash adapter, some units can provide

Top: *Here is an example of getting close to the subject, yet still including many objects in the shot for an interesting still life composition. The lens used was a Sigma 18-35mm f/3.5-4.5 zoom with an orange filter. The lens was set at 24mm.*

Bottom: *This photo, which is a natural still life in an outdoor setting, presents a well balanced composition. The lens used was a Tokina 28-70mm f/2.6-2.8 zoom. The lens setting was 28mm.*

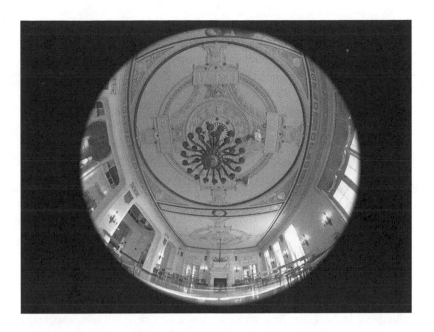

Top: This photo is an interior shot taken from a low position with a circular fisheye lens. The lens used was a Minolta 7.5mm fisheye f/4 lens. The camera was mounted on a tripod and the photo was shot using the existing light.
Bottom: This interior photo was also taken from a low position with an 18mm ultra-wide angle lens. The lens was a Sigma 18-35mm f/3.5-4.5. A tripod and existing light were used for this

flash coverage for lenses as wide as 18mm. The better flash units include tilt and swivel flash head features which give you more flexibility.

For more pleasing, natural looking light, bounce the flash off the ceiling or a piece of white board, or use a diffuser attachment instead of using a direct flash. Another way to evenly light a wide area is to use two remote slave flash units positioned at the perimeters of your subject. These units are for off camera use and will fire when your main flash unit is set off. This will help to illuminate the middle and edges of a scene for good wide-angle coverage. Slave units are relatively inexpensive and are a very useful addition to your photographic equipment.

Using Portable Flash Units

Finally, a more advanced technique for lighting interiors for wide-angle photography is to "paint" the interior with light from a portable electronic flash unit. This method of lighting works well with large dimly lit interiors when light levels are low enough to allow you to leave the shutter open for a long period of time. However, it also can be used to selectively lighten up dark areas of just about any interior, especially when your flash unit will not efficiently illuminate a very wide area. With this technique, mount your camera on a tripod, switch the shutter to the B (bulb) setting, and lock the shutter open with a cable release.

Next, quickly walk to the areas you want to illuminate with the flash and fire the unit manually by pressing the test button. Set the flash unit to the same aperture setting you are using on the lens so it will produce enough light to give you the correct exposure. Because the shutter may be open anywhere from thirty seconds to a few minutes, do not use a very wide aperture as this may result in an overexposed photo. The best advice is to make test exposures at various apertures based on the amount of existing light and the number of times the flash will be fired to illuminate the scene.

When firing the flash, try to conceal yourself behind objects in the room and move quickly so that the camera does not record you on the final image. (It helps to wear dark colored clothing.) When you decide on the length of the exposure, make sure you provide enough time to fire the flash as often as you need, allowing for the unit to recharge after each firing. If you wish to alter or enhance the color of the interior without using a filter over the lens, place a colored gel over the flash head.

"...PAINT THE INTERIOR WITH LIGHT..."

CHAPTER 7
Wide-Angle Fun

Giant Effects

You can have fun when you use wide-angle lenses, to photograph people, particularly when you use fisheye and ultrawide-angle lenses. Take advantage of the ability of these lenses to exaggerate the size of objects close to the lens and to diminish the size of distant objects.

For example, if you use an ultrawide-angle lens or full frame fisheye, you can make a person appear to be a giant holding a little person in its hand. You can do this by having someone as the "giant" stand close to the lens while the other person stands in the distance behind the "giant." The wide-angle lens will make the person seem even farther away and thus cause a reduction in size. Have the "giant" extend its arm out to the side with the palm of the hand turned up and level. Next, look through the viewfinder and position the person in the distance until it appears as if the "giant" is actually holding that person in its hand.

To make the person who is the "giant" look more imposing, take the shot from a low position. This effect works better with a wide-angle lens rather than a standard lens because of the narrow depth of field and wide angle of view which help render the people in the foreground and background in sharp focus. It also exaggerates the differences in their sizes. Use a small aperture for better results with this effect.

Facial Feature Effects

Another effect you can create uses a circular or full frame fisheye lens to distort people's facial features. Because objects that are very close to these lenses spread out and bend back giving a doorknob reflection effect, you can dramatically alter a person's facial features. Get as close to the person as the lens allows while staying in focus. This will allow the person's face to fill most of the frame with the focus staying sharp from the top of the head down to the chin.

Experiment by shooting at different angles and from high and low positions. Shoot from above and tilt down to make the head look large and the chin look small. From below, tilt up for the opposite effect. Don't just shoot full face shots; work on shooting profiles too.

Top and Bottom: *Who are these strange looking people?! You can have a lot of fun with distorted facial feature shots using a circular fisheye lens. These photos were taken with a Minolta 7.5mm fisheye f/4 lens and a yellow filter.*

Top: *The extreme foreground distortion is caused by shooting very close to the sub-ject with a 7.5mm circular fisheye lens. The lens used was a Minolta 7.5mm f/4 fisheye lens with a yellow filter.*
Bottom: *The extreme barrel distortion produced in this shot is from shooting close and low to the subject with a 7.5mm circular fisheye lens. Again, this shot was taken with a Minolta 7.5mm f/4 fisheye lens and a yellow filter.*

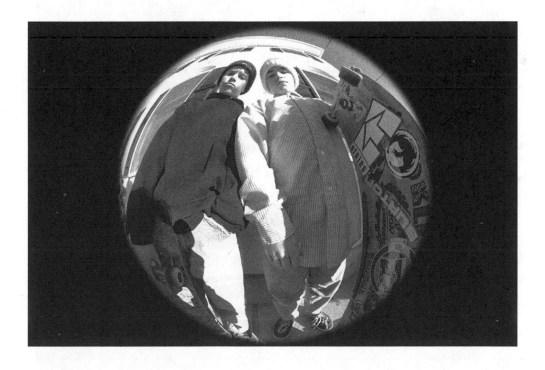

Top: *This photo was taken with a 18mm ultrawide-angle lens from a high position to create shortened stature. The lens used was a Sigma 18-35mm f/3.5-4.5 with an orange filter.*
Bottom: *This photo was taken with a 18mm ultrawide-angle lens, very close and low to the car to exaggerate and stretch the lines of the car. The lens used was a Sigma 18-35mm f/3.5-4.5 with an orange filter.*

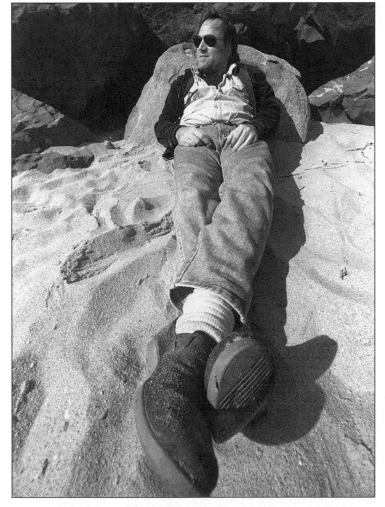

Top: *This shot was taken with an 18mm ultrawide-angle lens to create the "giant" effect. The lens used was a Sigma 18-35mm f/3.5-4.5 with an orange filter.*
Bottom: *This shot was also taken with an 18mm lens, very close to the feet of the subject to create a stretched out, longer appearance. The shot was made with a Sigma 18-35mm f/3.5 - 4.5 lens and an orange filter.*

"MAKE THE CREATION OF THESE PHOTOGRAPHS A GROUP EFFORT..."

Height Effects

You can also use a full frame fisheye or ultrawide-angle lens to alter someone's height by making a person appear taller or shorter than he or she really is. To make someone appear taller, get close to your subject and crouch down low, or lie on your back, while the person is standing. Aim the camera up and take a vertical shot. You can either shoot from head to toe, or from the lower torso up. To add to this illusion, put some small objects in the distance behind the person. This will make the person seem even taller. Make sure there are no elements in the scene such as a nearby tree that might ruin the effect.

To make someone appear to be much smaller, stand on a ladder or chair and aim the camera down and slightly off center from the top of the person's head. This viewpoint will make the subject look very short because the lens compresses everything. If you get closer, it will appear that the head is much too large in proportion to the body. You can make a horizontal or vertical shot and try to include the top of the person's feet for a more convincing illusion. If you can include a tall object that is close to the lens, it will enhance the effect. Make the creation of these photographs a group effort by getting family and friends involved in the production of wide-angle special effects.

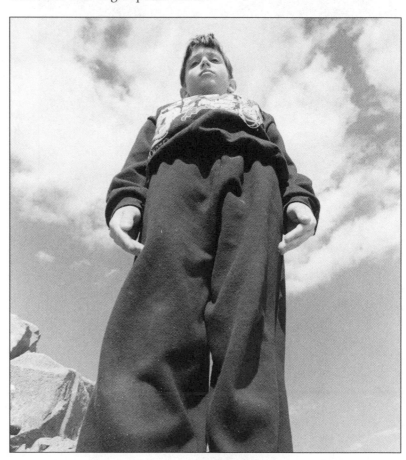

This photo was taken with an 18mm ultrawide-angle lens from a very low position to make a person look very tall. The lens used was a Sigma 18-35mm f/3.5-4.5 with an orange filter.

CHAPTER 8

Landscapes and Vacations

Organizing Visual Elements

Composition is the selection and arrangement of visual elements in a photograph. Organizing the visual elements is vital in conveying a message to the viewer. It also controls the way the viewer's eye moves across the image. There should be no random placement of elements in a scene.

Each element should be located in a specific position for a reason. The reason can be physical or aesthetic. A physical reason would be to direct the viewer's eye to a particular part of the image. An aesthetic reason would be to convey a message, or elicit an emotional response from the viewer.

Landscapes

Composition is the most important element in creating a good landscape photograph, and the relationship between the land and sky is an essential factor in composition. You need to fill the frame with interesting subjects and decide if the land or sky will dominate the photograph. Try to give your composition more sky or more land rather than an equal balance of both.

The placement of the horizon line in a scene is very important. If you place it in the middle of a scene, it will make the photo seem unbalanced and the viewer's eye will be unable to find a comfortable resting place. It will be torn between concentrating on the earth or the sky. It will also take the viewer's attention away from the background elements. Placing the horizon line higher in the scene will alter the photograph considerably. The eye will now be attracted to the foreground with the sky adding some interest. The sky will not be competing with the foreground for attention.

If you place the horizon line low in a scene, it will cause the sky to occupy most of the frame and it will become the main point of interest. The background elements will also be more prominent and will serve as a resting point for the viewer's eye, providing some relief from the visual impact of the sky.

> "...THE RELATIONSHIP BETWEEN THE LAND AND SKY IS AN ESSENTIAL FACTOR..."

"EVERYTHING, NEAR AND FAR, IN FOCUS!"

Example: At the Beach

The following example shows how you can use a sharp depth of field and low camera viewpoint to your advantage when photographing a scene. Suppose you are shooting a vertical of rocks on the beach and there are also cliffs in the distance you would like to include in the shot. To achieve a high horizon line, place the camera low to the ground, tilting the camera up enough to include the distant cliffs. Using a small aperture and focusing on the cliffs, take your shot. The final image will encompass a great wide-angle expanse of the nearby rocks (slightly elongated) and distant cliffs with everything, near and far, in focus. You can't do that with any lens other than a wide-angle.

Example: Rock Formations

For another example, suppose you are shooting a horizontal of huge rock formations in the distance; large boulders very close to the lens in the foreground, and a high cloudy sky above. Focus at infinity and use a small aperture. The wide-angle lens will record the distant rock formations, include the nearby boulders (stretching them out slightly), and capture the expanse of sky and clouds while keeping foreground and background in sharp focus. By keeping the camera viewpoint level to the subject, a moderate expanse of sky and clouds will be recorded in the scene.

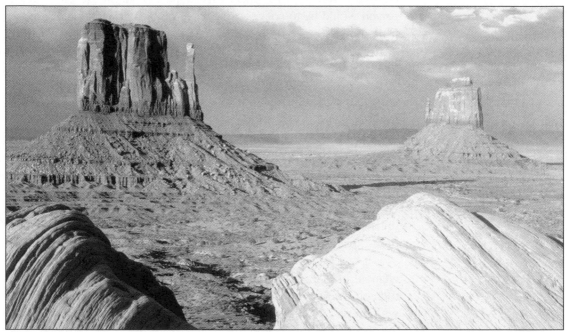

In this photo, the foreground and background remain in focus and the sky expands slightly. The lens used was a Sigma 18-35mm f/3.5-4.5 on the 24mm setting with a polarizing filter.

However, if you tilt the camera up from a slightly lower position, the area of the sky closest to the lens would expand out or diverge toward the lens and the area of sky farthest from the lens would converge away from the lens, creating a feeling of depth. If you were close to a subject

and tilted the camera up, as previously mentioned, the lines at the top of the frame would converge. The reason it does not happen in this situation, and the sky spreads out, is because you are far away from the subject. By tilting the camera up, more sky is recorded and the horizon line is no longer in the middle of the frame. The horizon line is now toward the bottom half of the frame so the proportion of sky area is greater than the foreground area.

This effect would be more pronounced if you used an ultrawide-angle lens due to its larger angle of view and shorter focal length. With ultrawide-angle lenses, the angle of view is greatly increased. To avoid ending up with a very small subject surrounded by large areas of empty space, move close to the scene to capture more detail and increase the size of distant elements while still capturing an expansive view.

Rule of Thirds

Try not to center your main subject in a scene. Leave an area of the frame without the subject by placing the subject left or right of center in a scene. When shooting with fisheye lenses, most objects, especially very wide buildings, will be centered in order to record the entire structure and eliminate unwanted elements. Placing the main subject in the upper or lower third of the frame will make for a more effective composition. This is known as the rule of thirds. The rule states that to draw attention to specific areas of your composition, mentally divide the viewfinder into thirds, horizontally and vertically. Position your main subject on one of the four points where the imaginary lines intersect. This will allow you to create a photograph that makes a strong visual statement by directing the viewer's eye to where you want it. This is easier to accomplish with a wide-angle lens as you have more space to work with when composing a scene due to the wider field of view.

Figuring the Best Angles

Walk around the area you are going to photograph and study it to discover the best angle or angles from which to shoot. Many people make the mistake of shooting from one viewpoint and one position; usually directly in front of the subject and at eye level. Avoid taking every shot from a horizontal viewpoint. Vertical compositions can be very powerful images, especially when using a wide-angle lens to exaggerate the height of an object.

Lighting

Light plays a very important role in landscape and travel photography. Morning or early evening light works best for producing warm colors and adding contrast and sharpness to objects. This is because the sun is at more of an angle to the scene at these times of the day, casting shadows that create depth by bringing out detail, texture and shapes in buildings, etc. The long shadows created by the low sun provide leading lines which are useful in drawing the viewer's eye to the main subject in a photograph. The ability of a wide-angle lens to elon-

gate objects will cause shadows to be exaggerated, especially when in the foreground of a scene, thus creating an increased sense of depth. When the sun is overhead, it creates hard lighting which causes everything to look flat therefore contributing to a loss of depth and detail.

An Exciting Adventure

Using a wide or ultrawide-angle lens helps to make travel photography an exciting adventure. It can stimulate your creativity by providing wonderful opportunities to stretch your photographic abilities, both figuratively and literally. Locations and landscapes will spread out in front of you as never before and you will be able to create impressive, eye-catching images that you and your family and friends will view over and over. With wide-angle lenses, you have a chance to capture images of the world around you as no one else can. Skies will expand, land will elongate and horizons will stretch out. You can bring a totally new perspective to all the photos you shoot.

> **"...CAPTURE IMAGES OF THE WORLD AROUND YOU AS NO ONE ELSE CAN."**

Vacation Photos

When traveling, first make sure you have all the equipment you will need. Make sure you bring as much film as you think you will need to photograph all the places you believe are of interest. Include different types of film such as color print, color slides and black and white. You might also wish to have a variety of film speeds on hand. Use 50 or 100 ISO/ASA for outdoor shooting, 200 ISO/ASA for indoor shots with a flash, or 400 or 1000 ISO/ASA for indoor shots without a flash. Bring batteries, filters, lens hoods, a flash unit, and a cable release and tripod. Take along a variety of lenses, or a wide-angle zoom lens. A wide-angle zoom will provide many lens options without taking up much room.

Vacation shots can be more exciting and dramatic by including a wider view of scene. This shot was taken with a Sigma 14mm f/3.5 ultrawide lens.

Aerial Photos

If you are traveling by airplane, you have a good opportunity to take some interesting wide-angle aerial photos. Get a window seat and just after take off, and just before landing, have your camera ready. Use a polarizing filter to remove glare or reflections from the window. Focus at infinity. Use a fast shutter speed of about 1/125 second and look for interesting shapes formed by land masses, water, roads, etc.

This photo was taken atop a lighthouse using an 18mm ultrawide-angle lens. As an aerial photo, it captures an extremely wide area of land and sea. The lens used was a Sigma 18-35mm f/3.5-4.5 zoom with an orange filter.

Landmark Photos

Most photographers realize that many of these landmarks have been photographed by millions of people and probably most of the shots have been taken from the same angles and camera viewpoints. You can take the obvious shot or find a new angle and perspective that has rarely or never been done. After all, you can use a wide, ultrawide-angle, or fisheye lens that will allow you to take the definitive shot.

When photographing famous landmarks, it is to your advantage to make use of wide or ultrawide-angle lenses in order to record the landmark in its entirety. It is the only way to capture the expansiveness and achieve a true sense of the overwhelming size of a large object in relation to its surroundings.

Example: Statue of Liberty

For example, if you were to photograph the Statue of Liberty with a wide or ultrawide-angle lens, you could position yourself close to the base and low to produce elongated foreground lines and converging lines at the top of the Statue. Shoot with a full frame fisheye and the

> *"...FIND A NEW ANGLE AND PERSPECTIVE THAT HAS RARELY OR NEVER BEEN DONE."*

Top: *This photo was shot with a 28mm lens that captures a landmark without cutting off the top or sides of the structure. The lens used was a Tokina 28-70mm f/2.6-2.8 lens.*
Bottom: *The expanse of the grand canyon is captured here by using a Sigma 18-35mm f/3.5-4.5 zoom lens on the 24mm setting.*

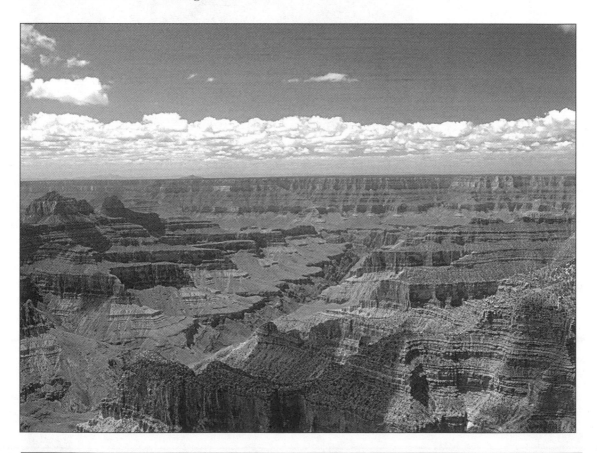

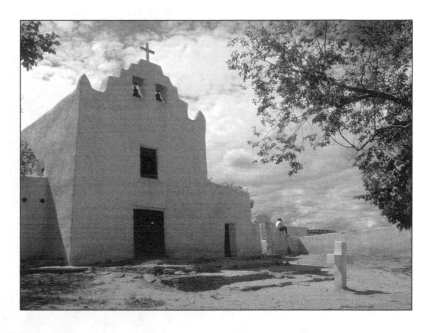

Top: This photo was taken with a 24mm lens to capture this landmark and its surrounding area. The lens used was a Sigma 18-35mm zoom f/3.5-4.5.
Bottom: Here is a 24mm view of a lighthouse and the ocean. The foreground is recorded for a well-balanced, scenic shot. The lens used was a Sigma 18-35mm zoom f/3.5-4.5.

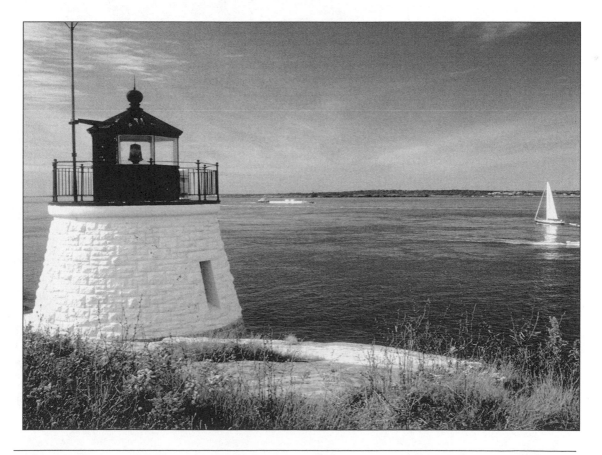

Statue will appear to be bending into the middle of the frame, seeming to tip over! The distortion you use to alter the vertical or horizontal lines will result in images that are truly one of a kind.

In this photo, the converging lines make the statue seem as if it is tipping over, creating a unique view of this landmark. Shot with a Sigma 18-35mm zoom f/3.5-4.5, set at 18mm and an orange filter.

Example: The Grand Canyon

You can shoot right from the edge of the scenic overlooks of the Grand Canyon with an ultrawide-angle lens (20mm, 18mm, or 14mm) to capture an extremely wide view that will retain a straight horizon line and record distant rock formations, the lower Canyon, foreground ledge, and nearby trees. If you shoot with a full frame fisheye lens and tilt the camera down, the horizon lines will bend down at the edges and the foreground ledge will curve down and expand out to the frame edges. The shot will also include the distant rock formations, lower Canyon, foreground trees (curved in) and possibly your own feet if you're not careful!

"...HORIZON LINES WILL BEND DOWN AT THE EDGES..."

Top: *Multiple images of fireworks are captured on a single frame of film using a tripod mounted camera, time exposure and 35mm lens. The lens used was a Tokina 28-70mm f/2.6-2.8 zoom.*
Bottom: *This beautiful night shot was taken with a Sigma 18-35 f/3.5-4.5 zoom lens, set at 18mm.*

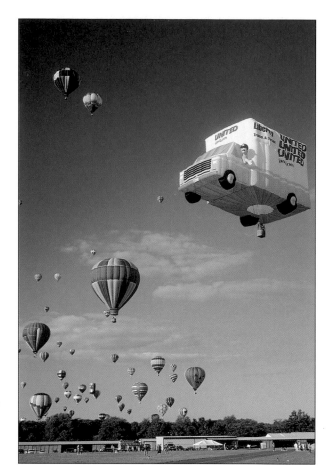

Top: *This scenic shot of hot air balloons comes to life using the 28mm setting on the Tokina 28-70mm f/2.6-2.8 zoom lens. A polarizing filter from Tiffen was also used.*
Bottom: *All the detail and fragile beauty of this rose is brought out by the Tokina 28-70mm f/2.6-2.8 zoom lens positioned on the macro setting. A Tiffen polarization filter was used.*

Top: *A full frame 16mm fisheye lens elongates foreground lines and leads the viewer's eye to this beautiful old ship. The lens used was a Minolta 16mm f/2.8 fisheye with a 1A filter.*
Bottom: *This photo, taken with a 18mm lens from a low position and close to the subject, records the true character of this antique auto. The lens used was a Sigma 18-35mm f/3.5-4.5 zoom with a Tiffen polarizing filter.*

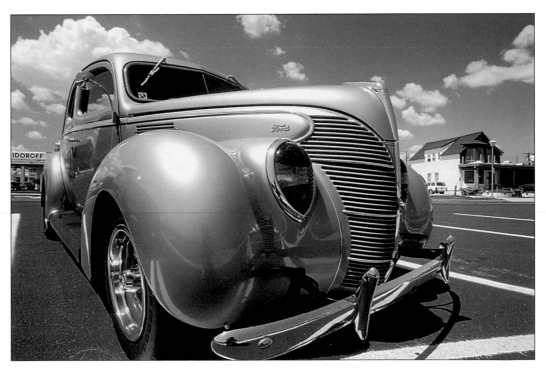

Top: *The elongated lines of the foreground barn door are due to a close and low camera position. The lens used was a Sigma 18-35mm f/3.5-4.5 zoom with a lens setting of 18mm. A Tiffen polarizing filter was also used.*
Bottom: *This photo, a worm's eye-view of this great hall, was taken with a 7.5mm circular fisheye from a low position using existing light. The lens used was a Minolta 7.5mm f/4 fisheye with a 1A filter.*

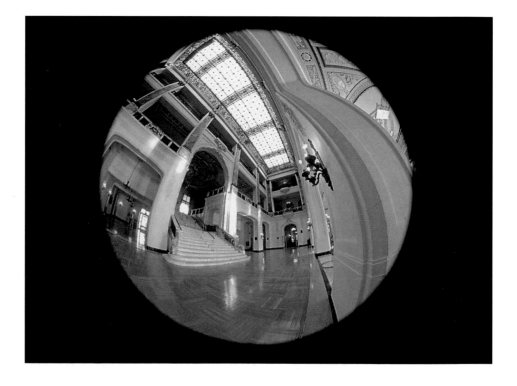

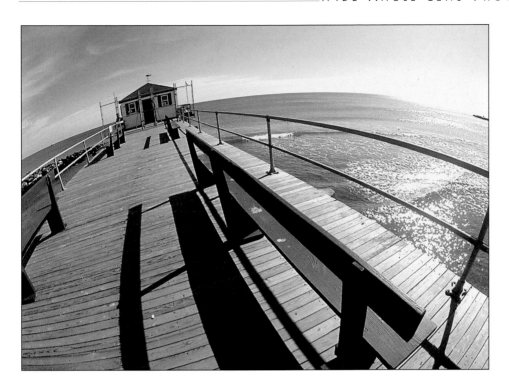

Top: *This photo was taken with the camera tilted down from a high position causing a curved horizon line and a bird's eye-view of the earth. The lens used was a Minolta 16mm full frame fisheye f/2.8 with a 1A filter.*
Bottom: *The curving lines of this trellis create an interesting woodwork pattern thanks to a circular fisheye lens and a low shooting point. The lens used was a Minolta 7.5mm f/4 fisheye with a 1A filter.*

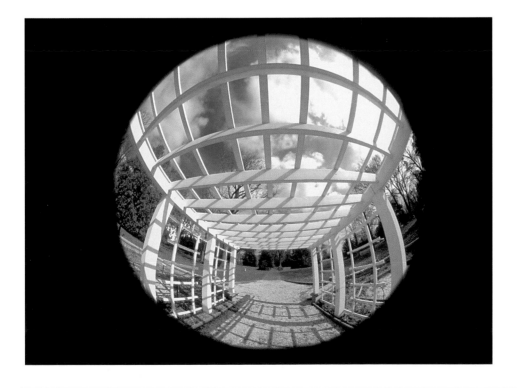

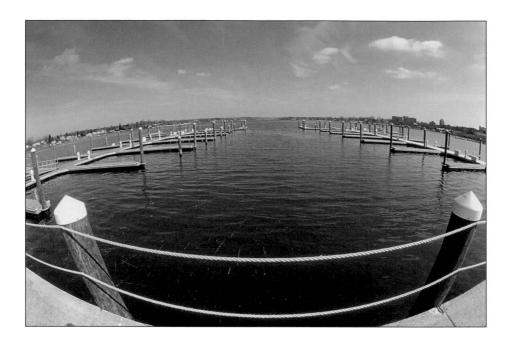

Top: *The curvature of the foreground and horizon lines is achieved by the camera being tilted down from a high position. A Minolta 16mm full frame fisheye f/2.8 lens was used with a 1A filter.*
Bottom: *A one-half block long hotel fits very nicely within the viewing area of a circular fisheye lens. The lens used was a Minolta 7.5mm f/4 fisheye with a 1A filter.*

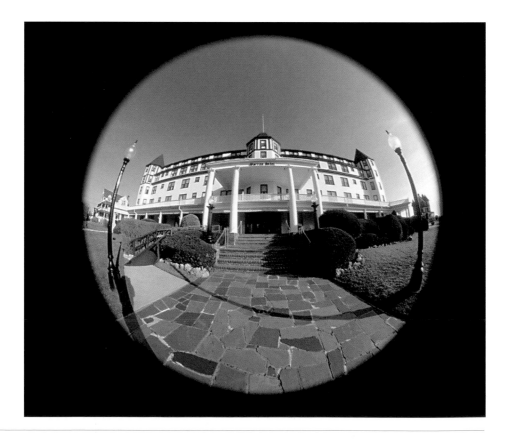

Top: *This beautiful shot of a house and wishing well was taken with a Sigma 14mm f/3.5 ultrawide-angle lens.*
Bottom: *A fisheye lens creates an interesting, eye-catching photo from what might be a boring initial subject. The lens used was a Minolta 7.5mm f/4 fisheye with a 1A filter.*

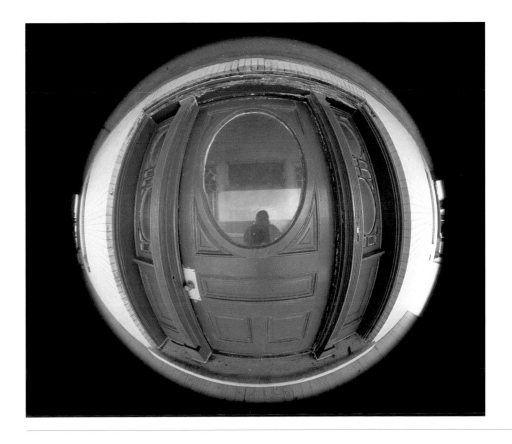

Top: *A beautiful beach in the Florida Keys looks very inviting and expansive. This wide-angle view was shot with a Tokina 28-70mm f/2.6-2.8 zoom with a lens setting of 28mm. A Tiffen polarizing filter was used.*
Bottom: *This amusement park building and ferris wheel are captured together in a wide-angle shot by using the Tokina 28-70mm f/2.6-2.8 zoom. The lens was set on 28mm and a Tiffen polarizing filter was used.*

Other Landmarks

Here are a few famous landmarks that come to mind and are difficult to photograph without the use of a wide-angle lens: the sweeping vistas of Yellowstone and Yosemite, the Leaning Tower of Pisa, Stonehenge, the Grand Canyon, the Brooklyn and Golden Gate Bridges, the Taj Mahal, the Capitol building, the Jefferson and Lincoln Memorials, the Parthenon, the Colosseum, the Sphinx, and the Pyramids. Because everyone is so familiar with well known landmarks, you can afford to be daring and bold with your compositions. Shooting Tip: Try to shoot famous landmarks earlier in the day when the lighting is more favorable and there are less people to get in the way.

Architecture Photos

When shooting architecture, look for elements and details that will add interest to your photograph. When photographing buildings, look for designs, strong color, warm light and abstract shapes that will strengthen your composition. Look for patterns that are repeated in architecture and use a wide enough lens to record as much of the pattern as possible for the best effect. You can also personalize a photograph using the detailed approach by getting close to the subject with your wide-angle lens and isolating a section of the subject.

> **LANDMARK SHOOTING TIP:**
>
> • Try to shoot famous landmarks earlier in the day when the lighting is more favorable and there are less people to get in the way.

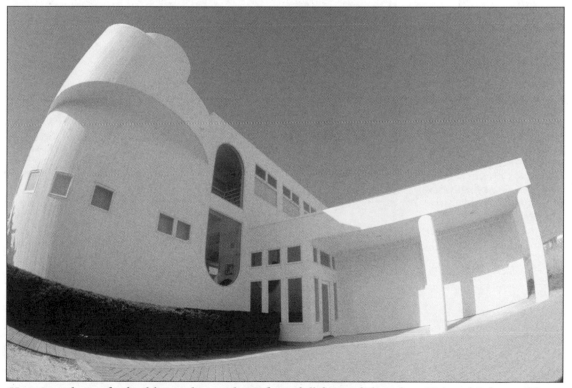

Here is a photo of a building taken with a 16mm full-frame fisheye lens. Using this lens adds interest to the structure by bending straight lines. The lens used was a Minolta 16mm fisheye f/2.8 with an orange filter.

Top: *This photo was taken with a 16mm full frame fisheye to capture the entire building and add interest by expanding the foreground and curving straight lines at the frame edges. The lens used was a Minolta 16mm fisheye f/2.8 with an orange filter.*

Right: *This photo was taken with a 28mm lens, close to the foreground archway to show perspective. The receding doorways create a unique view of an often photographed structure. The lens used was a Tokina 28-70mm zoom f/2.6-2.8.*

Top: *This photo was taken with a 16mm full frame fisheye lens from a low position tilted up. This angle creates an interesting view of the house for the photo. The lens used was a Minolta 16mm fisheye f/2.8 with an orange filter.*
Bottom: *This photo isolates and captures shapes, shadows, and texture. The lens used was a Sigma 18-35mm f/3.5-4.5 zoom set on 35mm with an orange filter.*

Emphasizing the Essence of the Structure

When photographing a building, you can emphasize the character or essence of the structure by using a wide-angle lens. Determine what features are visually critical and what your camera viewpoint will be. The viewpoint you choose is very important, so take the time to look the building over and find the most successful shooting position.

Look for elements near the building that can be used to add interest. Then decide how you want to alter the perspective and what you want to include or exclude from the scene. Make a visual note of how the relationship between the elements in the scene are altered as you change camera positions. Use your wide lenses to crop parts of a doorway or wall. Also use it to distort lines.

Time of Day

Also decide what time of day you want to photograph the building to take advantage of the best lighting. Photographing buildings illuminated by colorful artificial light at night can create powerful, impressive images. One way to capture the important features of a building in a creative way is to make use of light and shadows to emphasize size, shape, and perspective. You can also use the soft light from early morning, or shoot on a foggy or overcast day to create a subtle mood, thus producing unique atmospheric images.

Horizontal Buildings

Taking a wide-angle photo of a long horizontal building close up, and at an extreme angle from the corner of the building, will cause the receding lines of the building to converge toward the horizon. This will effectively elongate the length of the entire building, especially if shot with a 24mm or 20mm lens. When shooting a view of a waterfront skyline, use the foreground reflection of the buildings in the water for an added element of interest in your photo.

People

Photographing people in your travels is also a great way to become familiar with your surroundings. Instead of an impersonal shot using a telephoto lens from a distance, make the experience more personal by using your wide-angle lens to shoot close and interact with the person.Always ask for permission from the person. Don't be too intrusive, but talk to them and get them to relax. Always be sure to first have the person sign a model release form. If you make a person feel comfortable with you, they will usually agree to let you take their picture.

This is a great way to meet people and it also creates more picture taking opportunities. Shooting up close also allows you to bring out the character of a person's face. Use a 28mm or 35mm for less distortion of facial features. A wide-angle lens is also a great way to show people in their environment. You can fill part of the frame with the person while showing as much of the background as possible.

"...A GREAT WAY TO SHOW PEOPLE IN THEIR ENVIRONMENT."

CHAPTER 9
Advanced Shooting Tips

Using Fast Shutter Speeds

Controlling your shutter speed is an important factor in achieving a number of special effects. You need to use a fast shutter speed of 1/125 second or faster to freeze action and maintain detail in the subject. The faster the speed of the object, the faster the shutter speed must be to freeze the action.

No matter what the speed, an object moving across the viewfinder requires a faster shutter speed than one moving directly toward or away from the camera at the same speed. Also, a moving object near the camera or one appearing nearer due to the use of a telephoto lens (long focal length) requires a faster shutter speed than an object that is farther away. You need to use a slow shutter speed to emphasize motion, show movement, or make time exposures. A shutter speed of 1/30 or slower will cause a fast moving object to blur, losing sharpness and detail, but maintaining the appearance of movement.

For example, if you want to shoot a moving motorcycle, use a 28mm lens or wider to capture a wide field of view on either side of the motorcycle. Mount the camera on a tripod and use a cable release, a small aperture and a shutter speed of 1/30 second or slower. This will keep the background in sharp focus and blur the motorcycle, heightening the effect of motion. For best results, use a shutter speed slow enough to allow the motorcycle to come about 3/4 of the way into the frame, leaving some open space in front of it to enhance the feeling of motion.

Panning

Another technique for showing moving objects in motion is called *panning*. When panning, use a fast to moderate shutter speed of 1/125-1/60 second. Move your camera in the same direction as the moving object as it travels across the image area. Keep the subject located in the viewfinder and when the subject is positioned exactly where you want it, snap the shutter while you continue to move the camera. This effect will create a feeling of movement by blurring the background while the subject remains relatively sharp and detailed.

PANNING

Technique used to show a moving object in motion.

By moving your camera in the same direction as the moving object as it travels across the image area, the background will blur, but the subject will remain in sharp focus.

"...CREATE A FEELING OF MOVEMENT BY BLURRING THE BACKGROUND."

Using Slow Shutter Speeds

Slow shutter speeds are essential for slowing down or blurring the movement of running water from rivers, waterfalls or streams. Mount your camera on a tripod. Use a cable release and a small aperture of f/16 or f/22. Use a 28mm or 24mm to capture as much of the water as possible. For more impact, use a shutter speed of 1/2 to 3 seconds to produce a soft, ethereal look to the water.

Example: Fireworks

Wide-angle photographs of fireworks are wonderful because you can incorporate a wider area of sky on which you can record multiple images of light on one frame of film. This eliminates having to make a conventional double exposure. Begin by mounting your camera on a tripod, then set your aperture to f/8 or f/11 and move the shutter to the B (bulb) setting which allows you to keep the shutter open for as long as you decide.

To record a single image of fireworks on one frame of film, use your cable release to keep the shutter open and release it after the firework has gone out. Buy a cable release that can lock the shutter open. To record multiple images of fireworks on one frame, keep the shutter open to record as many bursts as you desire.

A good tip is to put the lens cap over the lens in between each burst when recording multiple images. This will keep the sky darker and minimize any elongation of the firework trails. This keeps each burst more detailed.

Example: The Night Sky

You can create wonderful wide-angle photographs of the night sky by recording the star patterns created by the rotation of the earth. Use a 24mm or 28mm lens for a wide field of view to record a more extensive pattern of movement. Use a 100 or 200 speed film and mount your camera on a tripod. Set your aperture between f/5.6-f/16 and move the shutter to the B (bulb) setting.

Find the brightest area of stars in the sky, away from any ambient light sources, and use your cable release to lock the shutter open for up to six hours! The longer the shutter is open, the wider the arc of light from the stars. Be aware that the longer the exposure, the lighter and less dense the sky will appear. The use of a very small aperture is therefore a priority.

If you leave the shutter open for six hours, you will need to set your alarm so you can get up before the sun rises and ruins your shot! If you must keep the exposure meter on to keep the shutter open, it can drain the batteries, so test them to see if they need to be replaced before or after you make your shot. Your final image will have arcs of light zooming across a wide-angle shot of the night sky. It will appear as if a meteor shower were raining down on earth.

SHOOTING TIP –
FIREWORKS:

• Put the lens cap over the lens in between each burst when recording multiple images

"IT WILL APPEAR AS IF A METEOR SHOWER WERE RAINING DOWN ON EARTH."

Top: *Here is a 35mm shot using a slow shutter speed of 2 seconds and tripod mounted camera to slow down the movement of the water and produce a soft, tranquil effect. The lens used was a Tokina 28-70mm f/2.6-2.8 zoom.*
Bottom: *By panning while the subject is moving, you can enhance the feeling of movement. The lens used was a Sigma 18-35mm f/3.5-4.5 zoom set at 20mm. The shutter speed was set at 1/125 sec.*

Top: *In this photo, the use of zoom streaks increases the impression of speed with this moving object. The blurred streaks are created by zooming your lens from the longest focal length to the shortest (or vice versa). The lens used was a Sigma 18-35mm f/3.5-4.5 zoom, set at f/11 at 1/15 sec.*
Bottom: *This night shot uses zoom streaks from neon lights to create a stunning light show. The lens used for this shot was a Sigma 18-35mm f/3.5-4.5 zoom, set at f/11 for 8 sec.*

Example: Lightning

When making photographs of lightning, use the same technique you use for photographing fireworks. Use an aperture of f/8 or f/11 and keep the shutter open to record single or multiple images of lightning bolts on one frame of film. You will achieve spectacular results. Make sure the storm is a safe distance away before you start to shoot, or shoot from the window of a safe, dry building or car. For best results, shoot through an open window. If that isn't possible, place the lens up close to the window and turn off any lights to minimize reflections.

Zoom Streaks

Another slow shutter speed special effect can be accomplished with a wide-angle zoom lens. This effect allows you to create blurred streaks by zooming your lens from the longest focal length to the shortest (or vice versa) during a long exposure. This will record your subject as a series of streaks shooting out from the center of a scene. This effect produces the appearance of motion with stationary objects and increases the impression of speed with a moving object.

> *"...INCREASES THE IMPRESSION OF SPEED WITH A MOVING OBJECT."*

The lens was zoomed during a long exposure in this shot to create zoom streaks. The lens used was a Sigma 18-35mm zoom f/3.5-4.5, set at f/5.6 at 1/30 sec.

ZOOM STREAKS

Zooming your lens during a long exposure to create blurred streaks that produce the appearance of motion with stationary objects, and increase the impression of speed with a moving object.

Zoom streaks work best when there is a wide range between the focal lengths of the lens. (For example, 28-105mm, 28-200mm, 35-135mm.) Only the center of the frame tends to remain somewhat in focus with this technique, so try to place your main subject in the center of the viewfinder. Use a shutter speed that will accommodate the time it takes to move the zoom (from 1/30-1/15 second). Mount your camera on a tripod for stability and set your zoom to the longest or shortest focal length. For example, with a 28-80mm zoom, set it at 28mm or 80mm. Focus on the subject, grip the zoom ring on the lens

and as you release the shutter, zoom the lens through the duration of the exposure. In order to produce long even streaks, make sure you zoom the lens smoothly.

The final image will result in a subject transformed into a series of vertical streaks radiating out to a wide expanse in the foreground of the scene. Photographs taken at night using this technique to record neon lights will produce spectacular results. The streaks created by the strong colorful light against a dark background greatly enhance the streak effect. For best results, switch your shutter to the B (bulb) setting and make time exposures of approximately 5 to 8 seconds at f/8-f/11. Wait a few seconds after you release the shutter to allow your subject to register before you start zooming.

Shooting Tall Vertical Forms

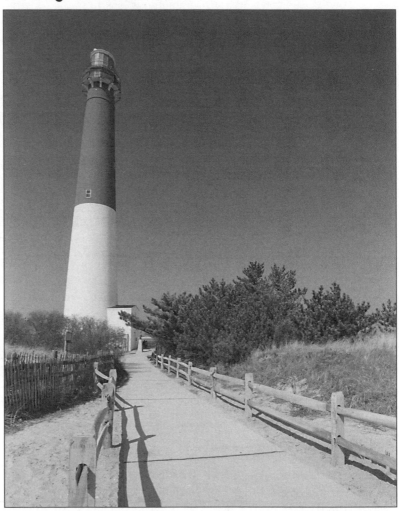

A Sigma 18-35mm f/3.5-4.5 zoom set at 20mm captured the lighthouse and walkway as well as a large expanse of sky and land.

When shooting tall vertical forms such as a lighthouse, monument, etc., using a wide or ultrawide-angle lens will enable you to capture not

only the structure, but the surrounding area as well. You can get close and shoot a horizontal photo and still record the entire structure. Placing the object to one side of the frame will allow you to record a wide stretch of land adjacent to it to show the relationship of the object to its surroundings. You can also move in very close and shoot verticals at unique angles to gain a perspective that will produce a stronger and more imposing image. In this way, you can bring an entirely new perspective to a familiar object.

Shooting from the top of a tall structure using a wide or ultrawide-angle lens is a great way to capture a tremendous expanse of sky, land and water to produce high altitude photos that appear to have been shot from an airplane or helicopter!

Foreground Objects

Including a foreground object in a scene is a good way to add information to a photograph. For example, if you want to photograph a famous landmark and there is a historic marker in the foreground that contains information about the landmark, you can include it in the shot when using a wide-angle lens. Even if the landmark is some distance away, stand close to the marker and use a small aperture; record the marker and landmark in the shot with everything remaining in focus.

You can get so physically close to a foreground object that it is beyond the closest focusing range of the lens. This will cause the nearest part of the object to be out of focus. It can even occur when using a wide or ultrawide-angle lens, but it will help give the appearance of more space between the foreground and background, strongly increasing the feeling of depth in a scene.

> "...A GOOD WAY TO ADD INFORMATION TO A PHOTOGRAPH."

A wide-angle lens was used to include a foreground object in a scene which adds interest to the shot. A Sigma 18-35mm f/3.5-4.5 zoom lens was set on the 24mm setting with an orange filter.

The technique of incorporating a foreground object into the top frame edge of a photo, such as a tree limb or doorway arch, to add an element of interest to the scene.

"...EXPOSURE CAN BE A LITTLE TRICKY."

Framing a scene with a foreground object is also easier to accomplish with a wide-angle lens as it includes the foreground without much effort. It also maintains background focus as well. Make use of the curving limb of a tree, the curve of an archway, or a similar object to draw attention to the main subject. Framing adds an element of interest to a scene emphasizing the subject and increasing the perspective.

Combining Indoor and Outdoor Views

Wide-angle lenses come in handy when shooting interiors and when combining indoor and outdoor views. With ultrawide-angle lenses, you can include the indoor foreground of a room and also capture the outdoor view through a large window or open door. This keeps both foreground and background in focus. If you take the shot without flash using existing light, exposure can be a little tricky. Take your exposure reading from a well-lighted area of the indoor scene, make that exposure, then close down one stop and make another exposure. Next, take your exposure reading from the outdoor scene and make one exposure at that reading. Finally, close the aperture down one stop from that reading and make one more exposure. This method of metering will ensure that you get a shot with a proper exposure and will decrease the chances of overexposure of the outdoor scene.

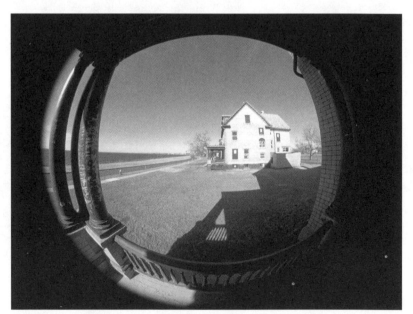

An indoor and outdoor view shot with a circular fisheye lens. Making the proper exposure may use up a few frames of film, but the final result is a photo with strong visual impact. The lens used was a Minolta 7.5mm f/4 fisheye.

Light

In general, when shooting interiors that are illuminated by sunlight, light levels will be high near the windows but darker elsewhere in the scene. If you expose for the brighter areas, your photograph will be

underexposed in the dark areas. If you expose for the darker areas, the windows and brighter areas will overexpose. The best advice is to take your meter reading from the darker areas and then bracket your exposures over and under the metered exposure.

In this way, you can then choose the shot that produces the best balance between highlight and shadow detail. Be aware that shooting indoors under artificial light with a daylight balanced color film will produce photos that will come out with a green or orange tone. The orange tone is produced by Tungsten light and can be corrected by using a blue No. 80A filter or Tungsten film with no filter. The green tone is caused by fluorescent lights and can be corrected by the use of an FL-D filter for daylight-type fluorescent lights, or an FL-W filter for use with warm white fluorescent lights.

Breaking the Rules

When using wide-angle lenses, break the rules that say everything has to look correct with as little distortion as possible. These lenses were made to allow you to create your own photographic vision. Make shots at every possible shooting position and angle. Use your imagination to its fullest! If you shoot a vertical of a tall building with a full frame fisheye, place the building near either frame edge and it will seriously curve into the frame producing a wild, surreal effect. Shoot the front grill of a car up close and it will stretch out and bend back across the entire image area. Wide, ultrawide-angle, and fisheye lenses will help you conceive and realize truly amazing photographs that have your own personal and unique point of view stamped on them.

"...CREATE YOUR OWN PHOTOGRAPHIC VISION."

Break the rules and use distortion to your advantage! The lighthouse looks as if it is made of rubber as it appears to be bending at a tremendous angle. This curvature is caused by a circular fisheye lens. Lens used was a Minolta 7.5mm f/4 fisheye.

CHAPTER 10

Taking Care of Your Wide-Angle Lens

Storing Your Lens

The best way to store your wide-angle lens is with both front and rear lens caps in place and secured in your camera bag. You can also keep the lens in a separate lens case. For added protection, store it that way in your camera bag. Individual lens cases are manufactured for a variety of lens sizes (including wide-angle zoom) and are usually available in the form of a soft-padded pouch or hard cylindrical case.

Cleaning the Lens

Always keep the lens elements clean to minimize lens flare from strong light sources and avoid blurred images. When the lens needs cleaning, first make sure you gently blow off any dust or dirt so that you don't scratch the lens. You can accomplish this by using a lens brush, bulb blower, or canned air. Next, to thoroughly clean the lens elements (front and rear), use a lens cleaning tissue and photographic lens cleaning fluid. Always apply the fluid to the tissue, not directly to the lens, to avoid the possibility of the fluid entering the inside lens elements. Lens cleaning products are manufactured by many companies and can be found at your local photo dealer.

"ALWAYS KEEP THE LENS ELEMENTS CLEAN..."

Always keep the lens elements clean to minimize lens flare from strong light sources and avoid blurred images. This lens is the Vivitar 28-80mm f/3.5-5.6 Macro focusing zoom.

APPENDIX A
Lenses and Manufacturers

Wide-Angle Lenses and Manufacturers

Wide-Angle	Manufacturer	Speed	Mount •	Focus
24mm	Nikon	f/2.8	N	MF
24mm	Nikon	f/2	N	MF
24mm	Nikon	f/2.8	N	AF
28mm	Nikon	f/1.4	N	AF
28mm	Nikon	f/2	N	MF
28mm	Nikon	f/2.8	N	AF
28mm	Nikon	f/2.8	N	MF
35mm	Nikon	f/1.4	N	MF
35mm	Nikon	f/2	N	AF
35mm	Nikon	f/2.8	N	MF
35mm	Nikon	f/2	N	MF
24mm	Olympus	f/2	O	MF
24mm	Olympus	f/2.8	O	MF
28mm	Olympus	f/2	O	MF
28mm	Olympus	f/2.8	O	MF
35mm	Olympus	f/2	O	MF
35mm	Olympus	f/2.8	O	MF
40mm	Olympus	f/2	O	MF
24mm	Sigma	f/2.8	C, M, P, S	AF
			For most cameras	MF
28mm	Sigma	f/2.8	C, M, N, P, S, Y	AF/MF
28mm	Sigma	f/1.8	C, M, N, S	AF
			For most cameras	MF
28mm	Canon	f/2.8	C	AF
24mm	Canon	f/2.8	C	AF
28mm	Canon	f/2.8	C	AF
28mm	Canon	f/2	C	MF
35mm	Canon	f/2	C	AF
35mm	Canon	f/2.8	C	MF
28mm	Minolta	f/2	M	AF/MF
28mm	Minolta	f/2.8	M	AF/MF
24mm	Minolta	f/2.8	M	MF/AF
35mm	Minolta	f/1.4	M	AF/MF
35mm	Minolta	f/2	M	AF/MF
24mm	Pentax	f/2	P	AF
28mm	Pentax	f/2.8	P	AF
28mm	Pentax	f/2.8	P	AF
28mm	Pentax	f/2	P	MF

Wide-Angle	Manufacturer	Speed	Mount	Focus
28mm	Tokina	f/2.8	C, CX, M, N, O, P, Y	MF
24mm	Tamron	f/2.5	For most cameras	MF
24mm	Vivitar	f/2.8	C, CX, M, N, O, P, Y	MF
28mm	Vivitar	f/2.8	C, CX, M, N, P, O, Y	MF
28mm	Yashica	f/2.8	Y	AF
24mm	Yashica	f/2.8	Y	AF

Ultra Wide-Angle	Manufacturer	Speed	Mount	Focus
20mm	Nikon	f/2.8	N	MF
20mm	Nikon	f/2.8	N	AF
18mm	Nikon	f/2.8	N	AF
15mm	Nikon	f/3.5	N	MF
13mm	Nikon	f/5.6	N	MF
20mm	Canon	f/2.8	C	AF
14mm	Canon	f/2.8	M	AF
15mm	Canon	f/2.8	C	AF/MF
20mm	Minolta	f/2.8	M	AF
18mm	Sigma	f/3.5	C, M, N, S	AF
			For most cameras	MF
14mm	Sigma	f/3.5	C, M, N, S	AF
			For most cameras	MF
20mm	Pentax	f/2.8	P	AF/MF
17mm	Tokina	f/2.8	C, M, N	AF
17mm	Tamron	f/3.5	O, P, Y	MF
19mm	Vivitar	f/3.8	For most cameras	MF
18mm	Olympus	f/3.5	O	MF
21mm	Olympus	f/2	O	MF
21mm	Olympus	f/3.5	O	MF

Wide-Angle Zooms	Manufacturer	Speed	Mount	Focus
20-35mm	Nikon	f/2.8	N	AF
24-50mm	Nikon	f/3.3-4.5	N	AF
28-70mm	Nikon	f/3.5-4.5	N	AF
28-85mm	Nikon	f/3.5-4.5	N	MF
28-85mm	Nikon	f/3.5-4.5	N	AF
35-70mm	Nikon	f/2.8	N	AF
35-70mm	Nikon	f/3.3-4.5	N	AF
35-80mm	Nikon	f/4-5.6	N	AF
35-200mm	Nikon	f/3.5-4.5	N	MF
35-105mm	Nikon	f/3.5-4.5	N	AF
35-135mm	Nikon	f/3.5-4.5	N	AF
28-80mm	Minolta	f/4-5.6	M	AF
28-105mm	Minolta	f/3.5-4.5	M	AF
35-80mm	Minolta	f/4-5.6	M	AF
24-50mm	Minolta	f/4	M	AF
24-85mm	Minolta	f/3.5-4.5	M	AF
28-70mm	Minolta	f/2.8	M	AF

Wide-Angle Zooms	Manufacturer	Speed	Mount	Focus
28-80mm	Minolta	f/4-5.6	M	AF
28-85mm	Minolta	f/3.5-4.5	M	AF
35-70mm	Minolta	f/3.5-4.8	M	MF
35-70mm	Minolta	f/3.5-4.5	M	AF
24-35mm	Minolta	f/3.5	M	MF
24-50mm	Minolta	f/4	M	MF
28-70mm	Minolta	f/3.5-4.5	M	MF
35-200mm	Minolta	f/4.5-5.6	M	AF
20-35mm	Canon	f/3.5-4.5	C	AF
28-70mm	Canon	f/2.8	C	AF
28-80mm	Canon	f/3.5-5.6	C	AF
28-80mm	Canon	f/3.5	C	AF
20-35mm	Canon	f/2.8	C	AF
28-105mm	Canon	f/3.5-4.5	C	AF
20-35mm	Canon	f/3.5	C	MF
35-80mm	Canon	f/4-5.6	C	AF
35-105mm	Canon	f/4.5-5.6	C	AF
35-135mm	Canon	f/4-5.6	C	AF
35-350mm	Canon	f/3.5-5.6	C	AF
21-35mm	Sigma	f/3.5-4.2	M, N,	AF
			C	MF
24-50mm	Sigma	f/4-5.6	M, N, S	AF
			C, P	MF
28-70mm	Sigma	f/2.8	C, M, N, S	AF
			For most cameras	MF
28-70mm	Sigma	f/3.5-4.5	C, M, N, P, S	AF
			For most cameras	MF
28-70mm	Sigma	f/2.8-4	For most cameras	AF/MF
28-105mm	Sigma	f/4-5.6	C, M, N, P, S	AF
			For most cameras	MF
24-70mm	Sigma	f/3.5-5.6	C, M, N, P, S	AF
			For most cameras	MF
18-35mm	Sigma	f/3.5-45	C, M, N, S	AF
			For most cameras	MF
28-200mm	Sigma	f/3.8-5.6	C, M, N, P, S	AF
			For most cameras	MF
35-80mm	Sigma	f/4-5.6	C, M, N, P, S	AF
			For most cameras	MF
35-135mm	Sigma	f/4-5.6	C, M, N, S	AF
			For most cameras	MF
28-70mm	Tamron	f/3.5-4.5	M, N	AF
			For most cameras	MF
28-200mm	Tamron	f/3.8-5.6	C, M, N, P	AF
			For most cameras	MF
20-40mm	Tamron	f/2.7-3.5	C, M, N	AF
			For most cameras	MF
28-70mm	Tamron	f/3.5-4.5	M, N	AF
			For most cameras	MF
28-80mm	Tamron	f/3.5-5.6	C, M, N	AF

Wide-Angle Zooms	Manufacturer	Speed	Mount	Focus
24-70mm	Tamron	f/3.3-5.6	C, M, N	AF
35-90mm	Tamron	f/4-5.6	N	AF
35-105mm	Tamron	f/2.8	C, M, N	AF
			For most cameras	MF
35-135mm	Tamron	f/3.5-4.5	For most cameras	MF
24-40mm	Tokina	f/2.8	C, M, N	AF
			For most cameras	MF
28-70mm	Tokina	f/2.6-2.8	C, M, N	AF
28-70mm	Tokina	f/2.8	C, M, N, P	AF
28-80mm	Tokina	f/3.5-5.6	C, M, N	AF
28-200mm	Tokina	f/3.5-5.6	M, N	AF
28-200mm	Tokina	f/3.5-5.3	C, M, N, O, P, Y	MF
20-35mm	Tokina	f/3.5-4.5	C, M, N, P	AF
28-70mm	Tokina	f/3.5-4.5	C, M, N, O, P, Y	MF
24-70mm	Tokina	f/3.5-4.8	C, M, N, O, P, Y	MF
28-105mm	Tokina	f/3.5-4.5	C, M, N, O, P, Y	MF
35-70mm	Tokina	f/3.5-4.8	C, M, N, O, P, Y	MF
28-70mm	Tokina	f/2.8-4.5	C, M, N, P	AF
28-85mm	Olympus	f/3.5	O	AF
28-105mm	Olympus	f/3.5	O	AF
35-200mm	Olympus	f/3.8	O	AF
35-70mm	Olympus	f/3.5-4.5	O	AF/MF
35-70mm	Olympus	f/3.6	O	MF
35-105mm	Olympus	f/3.5-4.5	O	AF
35-80mm	Olympus	f/2.8	O	MF
24-50mm	Pentax	f/4	P	AF
24-80mm	Pentax	f/3.5-4.7	P	AF
28-70mm	Pentax	f/2.8	P	AF
28-105mm	Pentax	f/4-5.6	P	AF
28-80mm	Pentax	f/3.5-4.5	P	AF
35-70mm	Pentax	f/3.5-4.5	P	AF
35-105mm	Pentax	f/4-5.6	P	AF
35-135mm	Pentax	f/3.5-4.5	P	AF
35-80mm	Pentax	f/4-5.6	P	AF/MF
19-35mm	Vivitar	f/3.5/4.5	C, M, N	AF
28-70mm	Vivitar	f/2.8	C, M, N	AF
28-70mm	Vivitar	f/3.5-4.5	For most cameras	MF
28-105mm	Vivitar	f/4/5.6	C, M, N	AF
28-200mm	Vivitar	f/3.8-5.6	C, M, N	AF
28-80mm	Vivitar	f/3.5-5.6	C, M, N	AF
28-210mm	Vivitar	f/3.5-5.6	C, M, N, O, P	AF
28-105mm	Vivitar	f/2.8-3.8	For most cameras	MF
17-28mm	Vivitar	f/4-4.5	C, CX, M, N, O, P, Y,	MF
28-80mm	Vivitar	f/3.5-4.8	C, CX, M, N, O, P, Y	MF
28-105mm	Vivitar	f/3.5-4.5	C, CX, M, N, O	MF

Wide-Angle Zooms	Manufacturer	Speed	Mount	Focus
28-300mm	Vivitar	f/4-6.3	C, M, N	AF
28-80mm	Yashica	f/3.9-4.9	Y	MF
35-70mm	Yashica	f/3.5-4.5	Y	MF
35-105mm	Yashica	f/3.5	Y	AF
28-70mm	Yashica	f/3.5-4.5	Y	AF

Fisheye Lenses	Manufacturer	Speed	Mount	Focus
6mm	Nikon	f/2.8	N	MF
8mm	Nikon	f/2.8	N	MF
16mm	Nikon	f/2.8	N	MF
16mm	Nikon	f/2.8	N	MF
7.5mm	Minolta	f/4	M	MF
16mm	Minolta	f/2.8	M	AF
15mm	Canon	f/2.8	C	MF
8mm	Sigma	f/4	C, CX, M, N, O, P, Y	MF
15mm	Sigma	f/2.8	For most cameras	MF
8mm	Olympus	f/2.8	O	MF
16mm	Olympus	f/3.5	O	MF
17-28mm (zoom)	Pentax	f/3.5-4.5	P	AF

Special Purpose Wide-Angle PC Lenses	Manufacturer	Speed	Mount	Focus
28mmPC	Nikon	f/3.5	N	MF
35mmPC	Nikon	f/2.8	N	MF
24mmPC	Olympus	f/3.5	O	MF
35mmPC	Olympus	f/2.8	O	MF
28mmPC	Pentax	f/3.5	P	MF
24mmTS	Canon	f/3.5	C	MF
45mmTS	Canon	f/2.8	C	MF

•Mounts have been abbreviated as follows: C - Canon (FD or EF); CX - Contax; M -Minolta (MD or A); N - Nikon (F, AL or AF); O - Olympus (OM); P - Pentax (K, KA or KAF); S - Sigma (SA); Y - Yashica.

APPENDIX B

Nikon Lenses

History of Nikon Wide-Angle Lenses

Nikon	_Wide-angle_	_Original Release_
6mm	Fisheye (Manual Focus)	1969
8mm	Fisheye (Manual Focus)	1970
16mm	Fisheye (Autofocus)	1973
16mm	Fisheye (Manual Focus)	1979
13mm	Manual Focus	1976
15mm	Manual Focus	1980
18mm	Manual Focus	1982
20mm	Manual Focus	1989
24mm	Manual Focus	1978
24mm	Autofocus	1991
28mm	Autofocus	1993
28mm	Manual Focus	1971
28mm	Autofocus	1991
28mm	Perspective Shift	1981
35mm	Manual Focus	1970
35mm	Autofocus	1988
35mm	Perspective Shift	1974
20-35mm	Autofocus	1993
24-50mm	Autofocus	1988
28-70mm	Autofocus	1993
28-85mm	Autofocus	1992
35-70mm	Autofocus	1992
35-80mm	Autofocus	1993
35-105mm	Autofocus	1991
35-135mm	Autofocus	1989
35-200mm	Manual Focus	1986

APPENDIX C

Ten Reasons for Shooting with a Wide-Angle Lens

10 – A wide-angle lens will help you see in a brand new way: your photos will have a unique visual perspective. (See page 7.)

9 – A wide-angle lens makes travel photography an exciting adventure -- locations and landscapes will spread out in front of you as never before! (See page 68.)

8 – You will be able to create dynamic images with a strong visual impact by incorporating many elements in a scene. (See page 8.)

7 – When taking pictures of many people together, wide-angles allow you to move in close and still get everyone in the shot. (See page 22.)

6 – Image distortion produced by some wide-angle lenses create great effects -- including "giant," "facial," and "height" effects! (See page 59.)

5 – When photographing famous landmarks, use a wide-angle lens to record the landmark in its entirety. (See page 69.)

4 – Emphasize the character or essence of an architectural structure by using a wide-angle lens. (See page 81.)

3 – Photographing a still life with a wide-angle lens improves your composition and visualization skills. (See page 54.)

2 – There are so many different ways to use a wide-angle lens - the possibilities are endless: landscapes, still lifes, interiors, vacations, travel, group, and sport photos, and so much more! It's a must for all serious photographers.

1 – Wide-angle lenses simply make picture taking fun!

Photo Notes from the Author

Cameras used to shoot the photographs for this book: Minolta x-700, Minolta Maxxum 400 si and 700 si.

All photographs that are 18mm, 20mm, and 24mm were shot using the Sigma 18-35mm f/3.5-4.5 wide-angle zoom lens.

Photographs that are 28mm and 35mm were shot using either the Tokina 28-70mm f/2.6-2.8 wide-angle zoom lens or the Sigma 18-35mm f/3.5-4.5 wide-angle zoom lens.

All photographs that are 16mm fisheye were shot using the Minolta 16mm f/2.8 lens.

All photographs that are 7.5mm circular fisheye were shot using the Minolta 7.5mm f/4 lens.

All photographs that are 50mm, 60mm, 70mm, and macro were shot using the Tokina 28-70mm f/2.6-2.8 wide-angle zoom lens.

Photographs that are 80mm, 100mm, 150mm and 200mm were shot using the Hoya 80-205mm f/3.8 zoom lens.

The photograph showing the use of a perspective control lens was shot using the Nikon 28mm f/3.5 perspective control lens and a Nikon F4S camera.

The black and white photographs were shot using either a no. 16 orange or no. 8 yellow filter.

A polarizing filter was used for all outdoor color photographs with all lenses except those taken with the 7.5mm circular fisheye and 16mm full frame fisheye, which were shot with a 1A filter.

GLOSSARY

ANGLE OF VIEW - The amount of area covered or viewed by a lens. From the same distance, a wide-angle lens covers an area greater than that of a normal (50mm) lens.

APERTURE - The lens opening through which light rays pass. The diaphragm of the lens determines the size of the aperture opening and controls the amount of light that reaches the film (as well as the depth of field).

ARROW-SHAPED COMA - The blurred or hazy border surrounding an object seen when viewed through a spherical lens. Aspherical lenses eliminate arrow-shaped coma as well as other spherical distortion.

ASPHERICAL LENS - A lens that incorporates special optical characteristics that minimize internal reflection and eliminate spherical distortions that contribute to image softness. These lenses focus the light evenly across the film plane for improved image sharpness and contrast.

BARREL DISTORTION - Occurs when a lens causes straight lines to bow out toward the edges of the picture frame. Frequently occurs with fisheye lenses.

CABLE RELEASE - An accessory that provides off-camera shutter release operation. It is essential when using a tripod mounted camera at slow shutter speeds to eliminate camera shake.

CAMERA VIEWPOINT - The specific placement of the camera to achieve the most effective composition.

CIRCULAR FISHEYE LENS - A wide-angle lens with a 180° angle of view that produces a circular image on film. The lens exaggerates perspective and causes outrageous distortion, especially around the edges of the image area.

CONTRAST - The visual difference in brightness between separate elements such as highlights and shadows.

CONVERGENCE - The coming together or merging of straight lines in an image caused by distortion from a wide-angle lens.

CURVILINEAR LENS - A wide-angle lens that produces image distortion by bending or curving straight lines in an image.

DEPTH OF FIELD - Area of sharpness in front of and behind the subject on which you are focused. Depth of field is determined by the size of the lens aperture and the distance from subject to camera. A smaller aperture will produce a large area in focus (sharp depth of field) and a larger aperture will produce a small area in focus (shallow depth of field).

DIVERGENCE - The distortion from a wide-angle lens that stretches or spreads out straight lines in an image.

F/STOP - Term that indicates the size of the aperture opening. The f/stop (aperture) is used to control the exposure and depth of field. The f/stop numbers are printed on a ring around the lens barrel. On some cameras, the f/stop numbers appear on a digital display screen on the camera body. A small f/stop number will produce a large aperture and shallow depth of field. A large f/stop number will produce a small aperture and greater depth of field.

FLARE - A decrease in contrast in the shadow areas of an image due to the reflection of light from lens surfaces and internal elements in the lens barrel. It is most likely to occur when shooting backlighted subjects. Multi-coated lenses reduce lens flare and improve the quality of the image.

FLOATING LENS ELEMENTS - Configuration of individual lens elements that move in relation to the distance at which the lens is focused. This reduces bulk and corrects flare, distortion and image sharpness. These elements allow the manufacturer to produce fast, compact and lightweight lenses.

FOCAL LENGTH - The distance from the optical center of the lens to the film when focused at infinity. The shorter the focal length of a lens, the wider the picture angle. The longer the focal length, the narrower the picture angle.

FRAMING - The technique of incorporating a foreground object, usually at the top of the frame, into the photograph to add an element of interest. The foreground object is usually a tree limb, curve of an archway, or other such elements to emphasize the subject and increase perspective.

FULL FRAME FISHEYE - A wide-angle lens with a 180° angle of view that bends and distorts straight lines across the entire width of the image area.

GHOST IMAGE - The colored lens flare caused by a point light source that manifests itself in the shape of the lens aperture.

IMAGE DISTORTION - The inconsistency between subjects and their representation on film.

LENS HOOD - Accessory that attaches to the front of the lens to reduce stray light, minimize flare and improve contrast and color saturation. Hard plastic and metal hoods offer shock protection for the lens.

LENS SPEED - Term based on the maximum aperture of a lens. Lenses are classified as either fast or slow. A 28mm f/2.8 lens is determined to be a fast lens because it has a maximum aperture of f/2.8. A 28mm f/3.5 lens is considered a slow lens because it has a maximum aperture of only f/3.5. The faster lens allows a greater amount of light to reach the film at its maximum aperture than the slower lens at its widest aperture.

MACRO - Term used for a lens that allows you to take extreme close-up photographs of small objects that reproduce at different magnification rations up to 1:1. For example, if the subject is 1/2 inch long in reality and on film it measures 1/2 inch long, the magnification ratio is 1:1 or "life size." If the same subject measures 1/4 inch long on film then the magnification ratio is 1:2 or one-half life size.

PANNING - The technique used to show a moving object in motion. When panning, the camera is moved in the same direction as the subject as it travels across the image area. A fast to moderate shutter speed is employed which will blur the background but keep the subject relatively sharp.

PANORAMIC CAMERA - A camera that creates super wide-angle images by recording an expansive view on one long piece of film through the use of a rotating lens or camera. These cameras produce magnificent distortion-free images.

PERSPECTIVE - This is the relative size of objects at various distances from the camera. For example, background objects will seem smaller with a 28mm lens than if you move back and shoot the same scene with an 80mm lens.

PERSPECTIVE CONTROL LENS - Lens that corrects converging lines in a subject through the use of a rotating, shifting lens barrel. Available in focal lengths of 24mm, 28mm and 35mm. Indispensable for architectural and interior photography.

PINCUSHION DISTORTION - Occurs when a lens causes straight lines to bow in toward the middle of the picture frame.

POLARIZING FILTER - Used to eliminate reflections from water, windows, etc., thus greatly improving contrast and saturating color.

RECTILINEAR LENS - A wide or ultrawide-angle lens that corrects barrel or pincushion distortion (curving or bending lines), thereby rendering straight lines straight.

SHARPNESS - The term used to describe the ability of a lens to record and reproduce subject detail clearly on film. A number of factors contribute to produce a sharp image including contrast, aperture and resolution.

SLAVE UNIT - A satellite flash unit placed away from the camera that fires a remote flash when the main flash is set off from the camera.

SPHERICAL DISTORTION (Aberration) - Occurs when a lens bends light rays passing through the edges more than those passing through the center so that they don't reach a common focal point on the film. The distortion produces unsharp, low contrast images.

SPHERICAL LENS - A convex shaped lens that has a tendency to gather light rays emanating from one point and bend them at angles that will not allow the light to reach a single focal point.

ULTRAWIDE-ANGLE LENS - A lens with an extremely short focal length and wide angle of view that is especially useful for travel, landscape, and interior photography.

VARIABLE f/STOP (Aperture) - In connection with wide-angle zoom lenses, the speed of the lens varies at different focal lengths. The maximum f/stop or aperture opening changes as the lens is zoomed. For example, with a 28-70mm f/2.8-4.3 lens, the maximum aperture at 28mm is f/2.8; at 70mm, the maximum aperture is f/4.3.

VARIABLE FOCUS - With regard to wide-angle zoom lenses, this term refers to lenses with a two-ring system of operation: One ring is for the zoom control and a separate ring for focusing. For ease of operation, zoom to the maximum focal length, focus, then zoom to any focal length and the subject will remain in focus.

VIGNETTING - The darkening of the image corners that usually occurs when a wide-angle or fisheye lens records the lens hood or filter mounts when filters are stacked in front of the lens.

ZOOM STREAKS - The blurred lines that occur when using a slow shutter speed while moving a zoom lens from short to long (or vice versa) focal lengths. These streaks emanate out from the center of a scene and will produce the appearance of motion from stationary objects. They can also be used to increase the impression of speed with moving objects.

INDEX

Other Books from Amherst Media

Basic 35mm Photo Guide
Craig Alesse

Great for beginning photographers! Designed to teach 35mm basics step-by-step—completely illustrated. Features the latest cameras. Includes: 35mm automatic and semi-automatic cameras, camera handling, f-stops, shutter speeds, and more! $12.95 list, 9 x 8, 112 p, 178 photos, order no. 1051.

McBroom's Camera Bluebook
Mike McBroom

Comprehensive, fully illustrated, with price information on: 35mm cameras, medium & large format cameras, exposure meters, strobes and accessories. Pricing info based on equipment condition. A must for any camera buyer, dealer or collector! $24.95 list, 8x11, 224 p, 75+ photos, order no. 1263.

Infrared Photography Handbook
Laurie White

Totally covers infrared photography: focus, lenses, film loading, film speed rating, heat sensitivity, batch testing, paper stocks, and filters. Black & white photos illustrate how IR film reacts in portrait, landscape, and architectural photography. $24.95 list, 8 1/2 x 11, 104 p, 50 B&W photos, charts & diagrams, order no. 1383.

The Art of Infrared Photography
Joseph Paduano

A complete, fully illustrated approach to B&W infrared photography for beginners and professionals. Features: infrared theory, filter use, focusing, film speed, exposure, and much more! $17.95 list, 9 x 9, 76 p, 50 duotone prints, order no. 1052.

Camera Maintenance & Repair
Thomas Tomosy

A step-by-step, fully illustrated guide by a master camera repair technician. Sections include: testing camera functions, general maintenance, basic tools needed and where to get them, basic repairs for accessories, camera electronics, plus "quick tips" for maintenance and more! $24.95 list, 8 1/2 x 11, 176 p, order no. 1158.

Make Fantastic Home Video
John Fuller

All the information beginning and veteran camcorder owners need to create videos that friends and relatives will actually want to watch. After reviewing the basic equipment and parts of the camcorder, this book tells how to get a steady image, how to edit while shooting, and more! $12.95 list, 7 x 10, 128 p, fully illustrated, order no. 1382.

Big Bucks Selling Your Photography
Cliff Hollenbeck

A strategy to make big bucks selling photos! This book explains what sells, how to produce it, and HOW TO SELL IT! Renowned West Coast photographer Cliff Hollenbeck teaches his successful photo business plan! Features setting financial, marketing and creative goals. Will help you to organize business planning, bookkeeping, and taxes. $15.95 list, 6x9, 336 p, Hollenbeck, order no. 1177.

Camcorder Tricks & Special Effects
Michael Stavros

Turn you camcorder into a toy! Over 40 tricks and effects show you how. With only a camcorder and simple props, you can simulate effects used by Hollywood pros. It's so easy, the whole family can join in the fun — even Rover! Enjoy creating video fun, and make your videos an adventure to watch. $12.95 list, 7x10, 128 p, order no. 1482.

Basic Camcorder Guide/ Revised Edition
Steve Bryant

For everyone with a camcorder, or those who want one. Easy and fun to read. Packed with up-to-date info you need to know. Includes: selecting a camcorder, how to give your videos a professional look, camcorder care tips, advanced video shooting techniques, and more. $12.95 list, 6 x 9, 96 p, order no. 1239.

The Freelance Photographer's Handbook
Fredrik D. Bodin

A complete handbook for the working freelancer. Full of how-to info & examples. Looks at marketing, customer relations, inventory systems & procedures for stock photography, portfolios, and increasing the marketability of your work. $19.95 list, 8 x 11, 160 p, order no. 1075.

Build Your Own Home Darkroom
Lista Duren & Will McDonald

This classic book shows how to build a high quality, inexpensive darkroom in your basement, spare room, or almost anywhere. Full information on: darkroom design, woodworking, tools, building techniques, ventilation, and more! $17.95 list, 8 1/2 x 11, 160 p, order no. 1092.

Underwater Videographer's Handbook
Lynn Laymon

Have fun shooting your own underwater videos! Fully illustrated and packed with step-by-step instructions on basic & advanced techniques, video dive planning, underwater composition, editing & post production and much more! $19.95 list, 8 1/2 x 11, 128 p, over 100 photos, order no. 1266.

Into Your Darkroom/ Step-by-Step
Dennis P. Curtin

The ideal beginning darkroom guide. Easy to follow and fully illustrated each step of the way. Full information on: equipment you'll need, setting up the darkroom, making proof sheets and much more! $17.95 list, 8 1/2 x 11, 90 p, hundreds of photos, order no. 1093.

Write or fax for a *FREE* catalog:
AMHERST MEDIA, INC.
PO Box 586
Amherst, NY 14226 USA

Fax: 716-874-4508

The Wildlife Photographer's Field Manual
Joe McDonald

The complete reference for every wildlife photographer. A complete technical guide, including info on: lenses, lighting, field exposure, focusing techniques, and more! Tips on sneaking up on animals, studio and aquarium photos, and much more! $14.95 list, 6 x 9, 200 p, order no. 1005.

Amherst Media's Customer Registration Form

Please fill out this sheet and send or fax to receive free information about future publications from Amherst Media.

CUSTOMER INFORMATION

DATE

NAME

STREET OR BOX #

CITY STATE

ZIP CODE

PHONE ()

OPTIONAL INFORMATION

I BOUGHT *WIDE-ANGLE LENS PHOTOGRAPHY* **BECAUSE**

I FOUND THESE CHAPTERS TO BE MOST USEFUL

I PURCHASED THE BOOK FROM

CITY STATE

I WOULD LIKE TO SEE MORE BOOKS ABOUT

I PURCHASE BOOKS PER YEAR

ADDITIONAL COMMENTS

FAX to: 1-800-622-3298

①

②

Name_____
Address_____
City_____State_____
Zip_____ — _____

Place
Postage
Here

Amherst Media, Inc.
PO Box 586
Amherst, NY 14226

③